The
Konica
Guide

The Konica Guide

A Modern Camera Guide Series

Lou Jacobs, Jr.

AMPHOTO
American Photographic Book Publishing Co., Inc.
Garden City, New York 11530

Library of Congress Cataloging in Publication Data

Jacobs, Jr., Lou.
 Konica guide.

 Includes index.
 1. Konica camera. 2. Photography—Handbooks,
manuals, etc. I. Title.
TR263.K55J34 771.3'1 78-18816

Library of Congress Catalog Card Number 78-18816
ISBN 0-8174-2121-1 (softbound)
ISBN 0-8174-2501-2 (hardbound)

Manufactured in the United States of America

Acknowledgements

My thanks to Peter M. Ildau, Vice President of Konica Camera Corporation, and the many other helpful personnel at Konica for supplying technical data and some of the illustrations in this book. Thanks to friends Eleanor Bralver and Harvey Hill for use of their photographs, and to my editors Herb Taylor and Cora Marquez, whose guidance I appreciate.

This guide is dedicated to all photographers who are turned on to the creative potentials of their Konica Autoreflexes for many styles of personal expression and fulfillment.

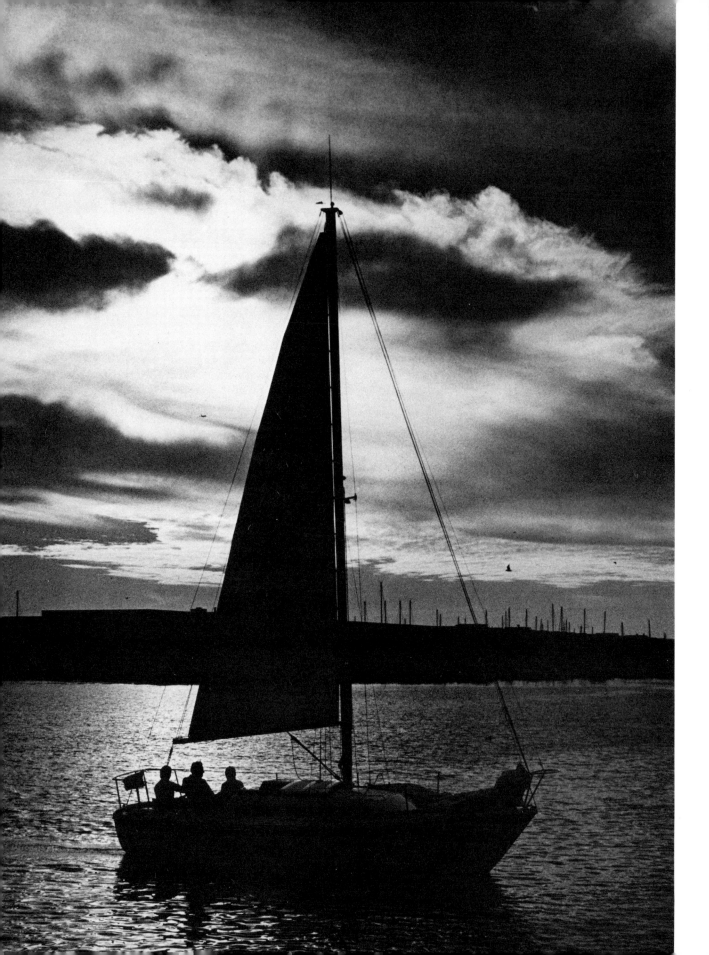

Table of Contents

Preface

In a relatively short time, Konica Autoreflex cameras have become favorite SLR's of amateurs and professionals alike. In the late 1960s, when the first Auto-Reflex was introduced, it was the *only* automatic-exposure 35 mm single-lens reflex available and acceptable to serious amateurs or professional photographers. For years afterward, there was a sense of disbelief among users of manual-exposure SLR's that an automatic exposure system could be trusted. Exposure automation had been limited to less expensive cameras, and the Autoreflex (it became one word) had to prove itself to demanding users.

Through word-of-mouth praise, highly complimentary test reports, and dealer recommendations, the Konica Autoreflex has taken an esteemed and *trusted* place in the crowded field of SLR's. Now there are many other brands offering automatic exposure systems, but Konica is acknowledged as the pioneer trademark that still sets a pace for others to follow.

Each new model of the Konica Autoreflex has offered improvements without complexities. The N-T3 has multiple-exposure capability; the TC has a compact configuration *with* auto-mation; and the new T4 combines the sophistication of an auto winder with the lightweight compactness that is so valued in today's state of the art. Even so, you may already know that Konica Autoreflex models are *not* the most expensive SLR cameras, although they have features not included in some higher-priced brands. One main reason for this is Konica's exclusive experience in the design and construction of quality automatic single-lens reflex 35 mm cameras. People benefit from company know-how when savings are passed on along with fine hardware.

In this third edition is a distillation of information from previous editions, plus many new photographs. At the time of this writing, the Konica T4 is so new that there has been barely enough time to run a few rolls of film through it. However, that was enough to start a love affair!

You'll discover facts and figures about Konica Autoreflex models that should prove valuable whether or not you are presently a Konica owner. In any case, you should experiment to the limits of your ability, and catch the joy of Konica photography.

Introducing the Konica Autoreflex

The Konica Autoreflex is a single-lens reflex (SLR) camera, the most popular type of 35 mm camera. The design of this camera has been improved and refined for more than 15 years, which accounts for its stature in the photographic field and its leadership in automation technology.

Let's look first at the main features that make the SLR unique and very desirable for the professional and amateur alike:

●When you view someone or something through the finder, you are looking directly through the lens via a mirror, a ground-glass screen, and a prism. There is no parallax, a problem that may occur with some 35 mm rangefinder cameras. With a Konica SLR, you and the lens see the same image that will appear on film and finished slides or prints.

●The range of focus possible with an SLR is unlimited. With Konica's special macro lenses or close-up attachments, you can focus on subjects only a few inches from the lens. With the standard 50 mm lens, you can focus down to a close 20 inches from a subject.

●An enormous variety of Konica lenses, in many focal lengths, is available for the Konica camera, making it a very versatile photographic tool. Whether you choose a telephoto, a wide-angle varifocal, or a zoom lens, you see the image precisely in the bright Konica viewfinder.

●A precise CdS exposure meter is built into the Konica camera for fast, accurate, automatic exposure control. The Konica Autoreflex metering system is fully automatic, modern, and labor-saving. Most important, it's economical, yielding properly exposed photographs roll after roll.

●You can accurately check the depth of field (the range of sharp focus from foreground to background in a scene) through the Konica viewfinder (T4).

●A wide range of shutter speeds and lens openings gives you positive control over interpretation and special effects in color or black-and-white photography. The SLR also has built-in flash synchronization.

Inside the single-lens reflex camera: 1. Pentaprism 2. Viewfinder 3. Ground glass 4. Mirror 5. Shutter 6. Film 7. Light/image

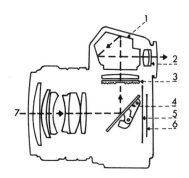

WHY THE KONICA AUTOREFLEX?

There are plenty of reputable SLR's on the market, making choosing a camera confusing. If you already own a Konica Autoreflex, the selection was a wise one. If you eventually buy one (or more), you will not regret it for reasons given throughout this book based on experih ence. Whether you compare the Konica with other SLR's on the basis of mechanical operation, reliability, optical excellence, lens options, or ease of shooting, you will find the Konica is outstanding and value priced.

The single, most important reason to choose a Konica Autoreflex model is its smooth, precise, automatic exposure system, which requires a minimum of concern on your part. Therefore, you are able to produce more "right-on" color slides or negatives. In addition, here are other reasons why the Konica continues to gain popularity:

●It's built to "take it"; it rarely needs servicing; and it takes a lot of "hard work," which in some cases means daily use for many weeks on assignment in Europe, and daily use of the various Konica cameras for many years at a time.

●The Konica system includes over 30 Konica factory-original lenses and hundreds of functional accessories—whatever the average photographer will ever need. They are lightweight and ultra-modern in design, and yet they are reasonably priced. With a Konica, you own a luxury camera for hundreds of dollars less than luxury price.

●Konica cameras are reliable and ingenious, so you can be more creative; but they are *not* complicated, nor do they include gadgets you may never use that boost the cost.

Automatic Operation

Here's a thumbnail preview of the Konica exposure system: Two exposure meter cells located within the viewfinder dome measure the light intensity and, by an adroit coupling mechanism, send signals to other interior components that set the correct lens opening *automatically* each time you shoot. Since you can

have full confidence in the meter's sensitivity to the slightest changes of light, you can concentrate on composition, timing, or facial expressions, rather than being bogged down with exposure calculations.

In simple terms, *you* choose the shutter speed, and the Konica Autoreflex sets the lens opening to match it exactly. There is no need for a hand-held exposure meter, nor do you need to twist rings or dials to adjust a needle or LED lights in the finder to get correct exposure. The precise results of Konica automatic exposure will amaze you if your experience with automation is limited.

Automatic exposure systems work by one of two methods, and it is advantageous to understand the difference between these two concepts. First, a review of the professional-method Konica system:

Konica "SP" automation—you set the shutter speed. From the beginning, the Konica Autoreflex was planned to parallel the average photographer's picture-taking techniques. In the predominant number of situations, you benefit by selecting the shutter speed to suit the action of the scene at hand. Konica automation then sets matching lens opening, also called *f*-stop or aperture. The company has long felt that this is the most efficient and professional approach, since the photographer always makes exposure decisions based on subject action and/or intensity of the light, which influences how steady the camera is held.

It's easy to understand the Konica "SP" (shutter-priority) system. You know that a car moves twice as fast on a 60 mph highway as on 30 mph streets. It's the same in setting the camera shutter speed—a shutter speed of 1/60 sec. is twice as fast as a shutter speed of 1/30 sec. A speed of 1/125 sec. is twice as fast as a speed of 1/60 sec. A speed of 1/250 sec. is twice as fast as a speed of 1/125 sec., and so on.

To "stop" or "freeze" the action of a fast-moving car, baseball player, or child, you must use a high shutter speed such as 1/250 or 1/500 sec.; however, to photograph a still life using a

tripod, you can work with 1/15 or 1/8 sec. if you wish. The Konica leaves these choices to you. When you need action-stopping shutter speeds, you *know* you have them with the shutter-preferred method of automation. In suitable light, you can just as easily select a slow shutter speed that allows the camera to set small lens openings to gain maximum depth of field.

In low light levels, when you have to hand-hold your camera, it is important that you know exactly the shutter speed set. The Konica system makes certain that *you* have this option. "Safe" shutter speeds for hand-held photography will vary with individuals and are covered in more detail later.

Aperture-preferred automation—you select the lens opening. Some camera manufacturers with newer automatic models have been limited to previous lens mounts, which require them to build automation into the camera body. Thus, the engineers have had to automate the shutters to allow the use of older design lenses which were made for their previous cameras.

To use this system, you must choose a lens opening (*f*-stop), after which the camera meter measures the light intensity and sets a shutter speed to coincide with the aperture you've set. In some cameras, you can see the *approximate* shutter speed the camera will use in a viewfinder display. During the moment of exposure, it is possible to lose track of this shutter speed as picture situations change. For instance, you may be shooting at 1/125 sec., and by turning a bit to where there's less light, the aperture-preferred system automatically has you shooting at 1/60 or 1/30 sec. At that speed, your subject may begin to blur when your intention is that it be sharp. You get the correct exposure; but with a slow shutter speed, you will probably get a "properly exposed blur." Of course, one can get used to the aperture-preferred method, though it doesn't offer the same feeling of confidence as the Konica shutter-preference mode. It's also nice to realize that Konica automation is not a compromise. It was originally designed to allow the choice of the shutter speed, and it has more than 15 years of experience behind it.

A BIT OF HISTORY

In 1973, Konishiroku, the company that manufactures Konica cameras, celebrated its first 100 years in the business. In the 1870s, only photographic and lithographic materials were marketed, but cameras were added to the product line by 1882, six years before George Eastman's roll-film Kodak camera was introduced. By the twentieth century, Konishiroku was making a number of different camera types, including a folding model in 1925 and a rangefinder type in 1948. By 1962, an automatic exposure system had been perfected for early rangefinder Konicas. The company had been designing and manufacturing its own lenses for many decades and in 1963, a large, new camera manufacturing complex was completed. Today, Konishiroku has an established reputation for quality scientific instruments, copiers, automatic color printers, graphic-arts equipment, and Sakura photographic papers and films, as well as for its cameras and lenses sold by the hundreds of thousands yearly on a world-wide scale.

The original Auto-Reflex.

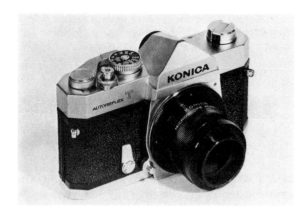
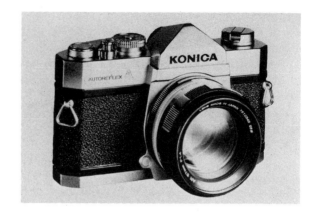

Introduced in 1968, the Konica Autoreflex models T (above left) and A (above right) both had internal through-the-lens metering.

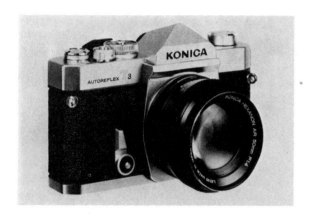
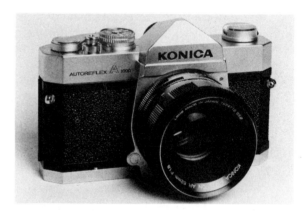

The Autoreflex model T3 (left) included such innovations as a multiple-exposure lever, and a removable hot shoe for flash synch. Introduced in 1972, the model A-1000 (right) offered a shutter speed of 1/1000 sec.

As a result of this lengthy optical and photographic experience, ingenious designers at Konishiroku adapted their auto-exposure system to a new camera concept in 1966 and called it the Konica Auto-Reflex. The camera also incorporated an instant-return mirror and quick-mount bayonet lenses. The meter "eye" on the old Auto-Reflex was located at the front of the camera within the shutter-speed dial. It worked fine, but not as accurately at very close distances as later models with built-in meters.

In 1968, the Konica Autoreflex models T and A were introduced. They looked alike and had internal through-the-lens metering and other improvements. The model A had a few less fea-tures than the model T. On these and on all Autoreflex cameras since, the meter automatically adjusts the lens aperture to provide the correct exposure, no matter what focal-length Konica lens you mount. In addition, the system is selective in that the meter reads more of the viewing area as longer-focal-length lenses are used. The advantages of this will be more fully explained later.

By 1970, there was an improved Autoreflex T offering refinements such as a shutter-release locking device that also turns the meter off and on, a smoother, shorter-travel shutter release, and shutter speeds visible at the bottom of the viewfinder. In 1971, the model A was improved

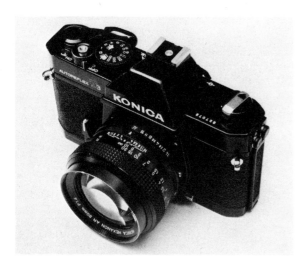

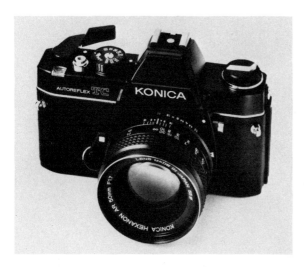

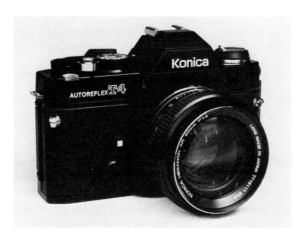

(Top) The new Autoreflex came along in 1975, with a different body style, and many other extras. (Center) The compact, lightweight, Autoreflex TC was added to the Konica line in 1976. (Bottom) The advanced Autoreflex T4 combines the qualities of the TC and the N-T3, and is available with an accessory Auto Winder.

for quieter shutter operation. Konica Hexanon lenses were fitted with a small locking button to prevent accidentally switching from EE or AE (automatic) exposure to the manual aperture.

In 1972, a new model A-1000 was also introduced, offering a 1/1000 sec. shutter speed on this less-expensive Autoreflex.

In 1973, came the Autoreflex T3 model with improvements and innovations such as a micro-touch shutter release, a multiple-exposure lever, a shutter-cocked indicator, automatic unlocking of shutter lock and meter activation as the film transport is turned, a film-tab holder, a removable hot shoe for flash synch, and a magnified film-counter window.

In 1975, a new version of the Konica Autoreflex came along called the N-T3, including new body styling, built-in hot shoe, restyled self-timer lever, improved multi-exposure lever, and a built-in eyepiece shutter or blind to block extraneous light when the eye is away from the eyepiece during an exposure. All these features and more are described in the next chapter.

In 1976, a new compact, lightweight Konica Autoreflex TC was added to the line, offering the same shutter-preferred automation and accepting the complete assortment of Konica Hexanon lenses, yet modestly priced. The TC is detailed in Chapter 3.

And now in 1978, the most advanced Konica Autoreflex, the T4, is introduced, combining the lightweight qualities of the TC with the sophisticated controls found on the N-T3. In addition, a new accessory Auto Winder is available for the T4, providing sequence photography at 1.8 frames per second. Both the T4 and its compact Auto Winder are described in detail in Chapter 4.

13

Imaginative effects are possible with the 15 mm Hexanon fisheye lens on an Autoreflex body.

Every Konica SLR since the beginning has included a vertical-travel, *metal* focal-plane shutter that offers durability and permits the use of higher shutter speeds (1/125 sec.) for electronic flash synchronization, a feature that many more-expensive SLR's still do not employ.

In brief, that's the story of Konica innovation and progress. Reliability has always been a goal of design and a product of workmanship. Each succeeding model has given photographers new conveniences without unnecessary complexities. Serious amateurs have consistently been ahead with Konica automation, and more professionals join Konica ranks yearly.

This delightful picture was taken by reader Harry J. Gould, with a 57 mm Hexanon f/1.4 lens. The Konica AE system gave him an ideal exposure of 1/1000 sec. in afternoon sunlight.

A PERSONAL VIEWPOINT

It seems appropriate in a camera guidebook to say something about the author. Most important, the Konica manufacturer is *not* paying me to write this book. I bought my own cameras and lenses at the beginning of the 1970s, before I knew the publisher would want a book. Thus, I am independent of Konica, except for technical data and some illustrations they kindly supplied. The enthusiasm I express for Konica cameras and Hexanon lenses is my own, based on plenty of opportunities to compare.

Back in 1938, I bought my first 35 mm camera — a rangefinder model of course — and 20 years later, I added an SLR to my equipment.

As a professional photographer since 1950, specializing in pictures for magazines, books, and industry, I've used several brands of single-lens reflex cameras. In the 1960s, I finally experimented with built-in camera meters, because like many pros, I was reluctant to trust a device to do what I was used to achieving manually. In due time, I came to have great respect and admiration for the modern technology that has given us cameras, meters, and lenses that were only dreams when World War II ended. And I consider the Konica Autoreflex one outstanding example of an optical-mechanical instrument that meets both the practical and emotional needs of most photographers.

SUMMARY

Photographs appear in later chapters, that were taken by one of my sons with a Konica Autoreflex when he was 12 and later as a teenager. His training has been minimal, but he understands the operation of a Konica, so he can focus sharply, load, unload, and shoot in various light conditions. He learned to use an SLR with an earlier match-needle brand (pre-Konica), and he suffered exposure disappointments just as I did. With an automatic-exposure camera, his confidence grew. Now my son and thousands of others can shoot qual-

ity photographs easily, under more relaxed circumstances.

The same may be said for insurance investigators, real-estate salesmen, police photographers, world travelers, writers, and virtually anyone who must shoot pictures for personal or business reasons without the help of a photography course. Along with enjoying automation and interchangeable lenses, these people can be more relaxed. The mistakes of exposure they might have made otherwise are largely compensated for by the camera. Less film is wasted. More good pictures are produced.

Note: An easy-to-read instruction booklet comes with the purchase of every Autoreflex. *Read it as thoroughly as this guidebook.* It digests the operating instructions found in this book as well, and has a lot of information you can absorb quickly. This book repeats some of the information in the manufacturer's instruction booklet, but does so in a personal, practical way. It shows and tells more fully and more interestingly in a longer, more complete format.

You may have heard the phrase that photography is a language, and you may speak it to express your sense of beauty or your wonderment at the world around you. Using a Konica to "speak" a visual language is a delight and a psychological boost. The camera does more of the work and gives you better opportunities to deal with the nitty-gritty of photography—making outstanding pictures.

Features of the Konica N-T3

As you open the instruction booklet that comes with the Konica N-T3, you may notice two things. First, the company calls the camera the T3, the same designation that appears on the camera, yet this chapter purports to be about the N-T3. "N" represents a new model with changes not extensive enough to add that letter to the camera body itself. There are several ways to distinguish the T3 and the N-T3, the easiest of which is by the white line on the N-T3 self-timer. There are other refinements as well, to give the N-T3 its own identity:

●The pentaprism is squared off as compared to the peak on the T3.

●The hot shoe is permanently attached.

●The multi-exposure lever has a new knurled finish for easier grip.

●There's a built-in eyepiece shutter to block extraneous light when your eye is not pressed against the viewfinder.

Second, on page 2 of the instruction booklet is a suggestion to shoot a "test" roll of film to verify that you are using your Konica correctly (*after* you have read the booklet).

And it's a good idea to check out your camera before doing some important work or leaving on a vacation. You should operate the camera without film *while* you read the instruction booklet, and while you review the operating features in this and following chapters of this book. In a so called "dry run," you understand the feel of camera functions and can perform some steps often without wasting film.

GENERAL FEATURES

The Konica Autoreflex N-T3, like the TC and T4, uses standard 35 mm film cartridges loaded with 20, 24, or 36 exposures. Each frame—the term used to describe an individual segment of exposed film—is approximately 24 × 36 mm or 1" × 1½". Lenses for the N-T3 are mounted and removed quickly by an oversized bayonet system that automatically links each EE or AE lens to the built-in meter. (*Note:* An older generation of Hexanon automatic-exposure lenses is marked EE, while newer models are marked AE.

All EE or AE lenses may be used on the N-T3, TC, T4, and on all other Konica SLR models.) The Konica N-T3 viewfinder includes a microdiaprism grid in the center for fine focusing. You may also buy the N-T3 model with a factory-installed split-image rangefinder screen, which can be a valuable help with wide-angle lenses and in dim-light situations. This split-image focusing device can also be installed in your N-T3 after you buy it. Ask your camera dealer or a Konica Service Center.

The Konica N-T3 is distinguished by a white line on the self-timer lever and the squared-off pentaprism.

The T3 has a pointed pentaprism and no line on the self-timer.

In the viewfinder, you see the shutter speed you selected and the *f*-stop determined by the camera at any specific moment. The viewfinder will be discussed later: first, here are specifications for the Konica N-T3:

Shutter. Metal, vertical-moving Copal Square-S. Shutter speeds from 1 sec. through 1/1000 sec. plus "B" for time exposures. Shutter lock is combined with meter on/off switch.

Meter EV range. With ASA 100 film and an *f*/1.2 lens, range is EV 1.5 to EV 18.

ASA range. 12–3200, or DIN 12–36 for European films.

Flash synchronization. Electronic flash on "X" terminal or hot shoe, 1 sec. through 1/125 sec. Flashbulbs and flashcubes on "M" setting or hot shoe, all speeds to and including 1/1000 sec.

Self-timer. Variable delay from 4 to 10 seconds. Timer automatically locks up mirror and stops down lens diaphragm *at the beginning* of the cycle to insure camera stability at time of exposure.

Meter power source. Two 1.35-volt mercury batteries, Mallory PX-675, Eveready EPX-675, or the equivalent. Built-in battery-check circuit.

Exposure-control system. Fully automatic exposure in which camera matches *f*-stop with user-selected shutter speed. Acceptance angle of meter varies with lens focal length, expanding as focal length increases. "Memory" lock via shutter-release button holds exposure reading in backlit or high-contrast situations.

Multiple-exposure control. Spring-loaded lever permits winding of shutter without advancing film or exposure counter.

Shutter-ready indicator. Green dot shows when shutter is cocked; red dot shows when shutter is uncocked.

Depth-of-field preview lever. Self-timer lever pressed towards lens stops down lens diaphragm to opening indicated by needle.

Dimensions with standard 50 mm lens. Height 3.9", width 5.9", depth 3.6". *Body only:* height 3.9", width 5.9", depth 1.8". *Weights:* body only, 26 oz. *Lens weights:* 50 mm *f*/1.7, 8.5 oz.; 50 mm *f*/1.4, 10.2 oz.; 57 mm *f*/1.2, 16.2 oz.

OPERATING FEATURES OF THE KONICA N-T3

All the operating features of the Konica Autoreflex N-T3 are labeled in the accompanying illustrations. You will recognize some immediately, and others may be new to you, but familiarity with all of them is basic to comfortable and confident camera techniques.

The Konica N-T3 is so versatile that the accompanying pictures plus most of the other camera details in this book were shot using another N-T3 fitted with the 55 mm macro Hexanon *f*/3.5 lens. A sheet of white cardboard was curved under the cameras as a background. Two 500-watt reflector flood bulbs were aimed at a hand-held piece of white cardboard that reflected the light to the cameras from above. This bounced or indirect light creates a soft ef-

Operating controls of the Autoreflex N-T3.

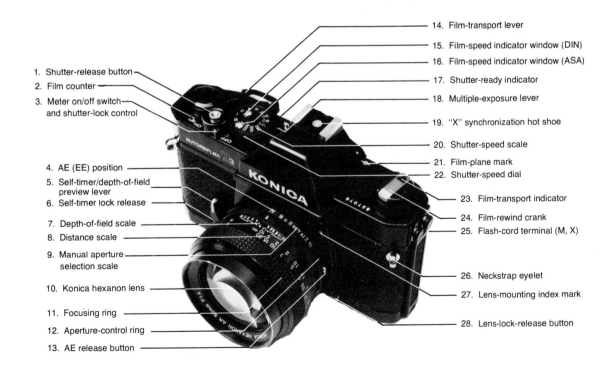

1. Shutter-release button
2. Film counter
3. Meter on/off switch and shutter-lock control
4. AE (EE) position
5. Self-timer/depth-of-field preview lever
6. Self-timer lock release
7. Depth-of-field scale
8. Distance scale
9. Manual aperture selection scale
10. Konica hexanon lens
11. Focusing ring
12. Aperture-control ring
13. AE release button
14. Film-transport lever
15. Film-speed indicator window (DIN)
16. Film-speed indicator window (ASA)
17. Shutter-ready indicator
18. Multiple-exposure lever
19. "X" synchronization hot shoe
20. Shutter-speed scale
21. Film-plane mark
22. Shutter-speed dial
23. Film-transport indicator
24. Film-rewind crank
25. Flash-cord terminal (M, X)
26. Neckstrap eyelet
27. Lens-mounting index mark
28. Lens-lock-release button

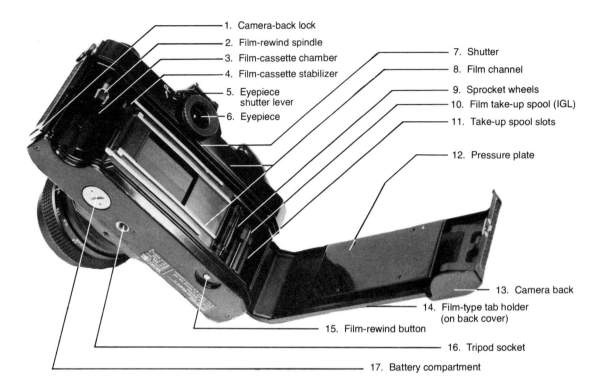

1. Camera-back lock
2. Film-rewind spindle
3. Film-cassette chamber
4. Film-cassette stabilizer
5. Eyepiece shutter lever
6. Eyepiece
7. Shutter
8. Film channel
9. Sprocket wheels
10. Film take-up spool (IGL)
11. Take-up spool slots
12. Pressure plate
13. Camera back
14. Film-type tab holder (on back cover)
15. Film-rewind button
16. Tripod socket
17. Battery compartment

Operating controls of the Autoreflex N-T3.

fect that shows form without harsh shadows. The film was Kodak Plus-X (ASA 125), and exposures averaged 1/15 sec. at f/11 and f/16. To compensate for the bright white background, the film-speed dial on the N-T3 was set at ASA 64, which gave proper negative detail with normal film development. See Chapter 9 for more information on exposure techniques.

INSERTING BATTERIES

Two mercury batteries power the Konica N-T3 meter. All shutter speeds work even if the batteries are weak or missing, but lens openings would have to be set manually and exposures guessed at unless a separate meter was used.

To insert fresh batteries, open the bottom battery chamber by turning the cover counterclockwise with a coin. Insert two Photographic Mallory PX-675 or Eveready EPX-675 1.3-volt mercury cells both *plus-side up.* Handle the batteries by their edges, and wipe them with a soft cloth if necessary. With batteries in place, screw the cover on again.

Mercury batteries should last about a year in "normal" use, which of course varies with individuals. When batteries weaken, the meter

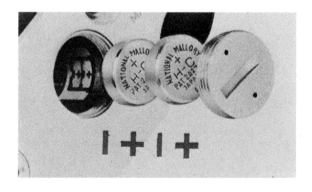

The Autoreflex uses either Mallory No. PX-675 or Eveready EPX-675 1.3-volt mercury batteries, inserted plus-side up.

tends to indicate overexposure. Use only 1.3-volt mercury photographic cells; many such batteries look alike but are not the same voltage. If you store the camera for several months, remove the batteries, wrap them in plastic, and freeze them to minimize deterioration.

BATTERY CHECK

There's a sticker on the bottom of each Konica Autoreflex listing the following steps for battery check:

1. Remove the lens by pressing the lens-release button and turning the lens counterclockwise.
2. Set the film speed to ASA 100 and the shutter speed to 1/125 sec.
3. Press the meter on/off switch *past* the "off" position to the "C" (check) position. If the meter needle in the viewfinder comes to rest within the red index mark labeled "battery test indicator" (see the illustration on p. 27), your batteries are okay. If the needle is above or below the test mark, it could mean your batteries need to be replaced. If batteries are fresh, and the needle does not align with the red test mark, the camera meter may not be correctly zeroed and should therefore be adjusted by a professional repairman.

As a reminder, the replacement date of batteries can be marked on a piece of cloth tape and fastened to the baseplate of each camera. On a trip one or two extra sets of mercury batteries should be taken along. If the climate is very hot or moist, battery life can be decreased by these conditions. A little bit of prevention can prevent problems from occurring.

After placing the film cartridge into its chamber, insert the film leader into any slot in the take-up spool.

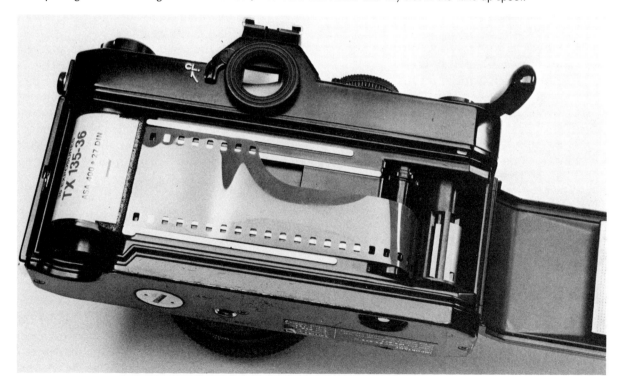

LOADING THE CAMERA

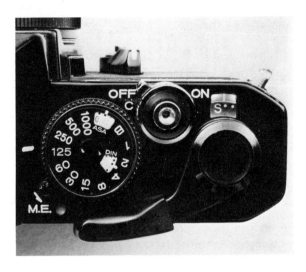

Be certain the on/off switch is off when you're not shooting pictures.

Find a shady spot, or shield the camera in the shadow of your body. Film cartridges are made well, but light leaks to the film are still possible under some conditions. Then load the camera as follows:

1. Press the camera-back latch and open the back cover all the way.
2. Slip the film cartridge into its chamber as shown in the accompanying illustration. There is no need to lift the rewind knob.
3. Pull the film leader across the picture-frame opening and insert it into any slot in the take-up spool.

4. Advance the film-transport lever as far as it will go several times, until the holes in the film are snugly fitted to the take-up sprocket and the leader is winding positively on the take-up spool.
5. Close the camera back and advance the film-transport lever two or three more times, pressing the shutter-release button between turns, until the "1" appears opposite the white index mark in the film-counter window.

Safety note: Never assume that your film is winding through the camera correctly unless you see the take-up spool revolving, because the exposure counter advances each time you operate the film-transport lever, whether film is being pulled through or not. For peace of mind, take the following precautions:

1. After closing the camera back, turn the rewind knob clockwise until you feel resistance. This takes up the slack within the film cartridge.
2. Watch the rewind knob as you advance the film to frame number one. This is visual insurance that you will get pictures on the film and that the film is not slipping on the take-up spool.
3. To reduce battery drain and prevent accidental exposures, flip the shutter-lock control to "off" when you're not taking pictures.

FILM ADVANCE AND REWIND

One stroke of the film-transport lever advances the film one frame forward, cocks the shutter, and moves the film counter to the next number. The counter totals up to 38 exposures with number 20 in red for shorter rolls of film.

Rewinding the Film

You'll feel the film tightening as you try to advance it at the end of the roll. Half a stroke will not cock the shutter, so prepare to rewind. *Don't force the film-advance lever in any cir-*

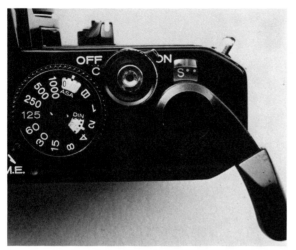

(Left) Advancing the film-transport lever turns the Konica metering system on and unlocks the shutter release. (Right) When you lift the rewind knob, there's a direction arrow beneath it.

cumstance. You can easily tear the film out of the cartridge and possibly damage the camera. If you do accidentally tear the film, unload the camera in total darkness and store the loose film in a lighttight container. Here is the rewinding procedure:

1. Depress the film-rewind button on the bottom of the camera. It will stay down unless the shutter is half-cocked, in which case the rewind button may pop up again as soon as rewinding starts. In that case, hold it down, rewind one frame or two, and fully cock the shutter. Press the rewind button again, and it will stay down during rewinding.

2. Lift the crank within the rewind knob and turn it in the direction of the arrow on the underside of the crank.

3. When rewinding is complete, you'll hear the film separate from the take-up spool, and the knob will turn freely. Now you can open the back of the camera—away from bright light. Remove the film cartridge and store it in its canister. A short strip of cloth tape can be placed on each canister, and then transferred to the side and top of the canister to indicate an exposed roll.

4. The rewind button pops out when you next advance the film-transport lever. If you are not going to use the camera immediately, depress the shutter release so the shutter is not cocked. In this way, the springs that regulate shutter speeds are under less tension and last longer. Also, replace the lens cap and use a body cap on the camera if no lens is mounted.

5. The film counter returns to "S" (start) when the camera back is opened, and you're ready for reloading.

Rewinding Film in Mid-roll

If you wish to switch from one type of film to another in mid-roll, e.g., from black-and-white to color, here's how:

1. Note the frame number you're on and rewind according to the instructions above.

2. Stop rewinding when there's tension on the knob. At this point, only the tip of the film leader should still be engaged in the take-up spool.

3. Open the camera back; mark the number of exposed frames on the film with a grease pencil; place the film in a canister, and mark it, too, with the number of frames exposed.

4. Reload with replacement roll.

When you're ready to use the unfinished roll, load it as usual, and *with the lens cap over*

This hand-held shot was taken with Tri-X film in a dimly lit railroad station using a 52 mm Hexanon lens at 1/15 sec. and f/2.8

the lens, advance the film and depress the shutter-release button until you are one frame beyond previously stopped number. Adding a frame helps avoid overlapped images.

SHUTTER AND APERTURE

Shutter

The all-metal Copal Square-S focal-plane shutter curtain of the Konica Autoreflex travels like a window blind vertically over the film plane for a pre-determined fraction of a second, represented by numbers on the shutter-speed dial. As the fractions increase in value, each speed is *double* the one before it, and as they decrease, each speed is *half* the one above it, numerically. The dial cannot be set for intermediate speeds between clicks. However, you may turn the dial any time before or after cocking the shutter.

"B" on the shutter-speed dial stands for "Bulb," a traditional term to indicate that the shutter stays open as long as the shutter button is depressed. The "B" setting is used for time exposures longer than 1 second. You may hold the shutter open on "B" by:

1. Finger pressure.
2. A cable release, preferably one that locks so you don't have to hold it during the full exposure.

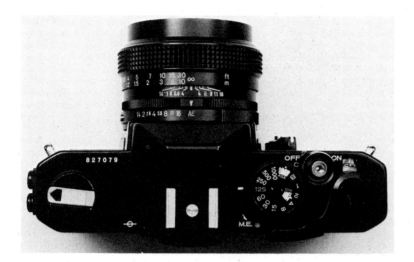

A top view of the Konica N-T3 shows the lens-aperture ring and shutter-speed knob for exposure control.

3. Pressing the shutter button down on the "B" position and twisting the meter on/off switch to the "off" position. This locks the shutter button down, and you can remove your finger. Turning the on/off switch to "on" closes the shutter at the end of the time exposure.

Fascinating things happen on film during long time exposures, and some are illustrated in Chapter 9. A tripod or other support should be used for your camera during exposures longer than 1/30 sec. Obviously, the faster the shutter speed, the less chance there is of getting a blurred image due to subject or camera movement. Therefore, whenever posible, shoot at 1/125 sec. or faster, but for speeds slower than 1/30 sec., mount your Konica on a tripod. Several comparison shots hand-held and with a tripod at slow shutter speeds will quickly show you the advantage of a firm support.

It's is a good idea to practice hand-holding the camera at 1/30, 1/15, and 1/8, and even 1/4 sec. to become familiar with the technique for occasions when you *must* shoot at a slow speed without a tripod. The accompanying illustration was taken at 1/15 sec., hand-held in a railway station where the light was dim. A 52 mm Hexanon lens was set at *f*/2.8, and the film was Kodak Tri-X rated at ASA 400. Though the image is not perfectly sharp, it is acceptable and well worth the gamble. Hold your breath during the exposure and brace your elbows against your chest. Brace yourself against a wall or pillar if one is available. Shoot a number of frames in such circumstances, because some camera shake is inevitable, and you hope to get quality from quantity.

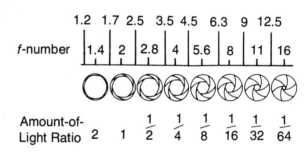

This diagram illustrates apertures related to the amount of light passing through the lens. As the *f*-number (top row) increases, the diaphragm closes and admits less light—half as much for each full stop (bottom row).

Aperture

The variable opening of a lens is referred to as the aperture, the *f*-stop, the iris diaphragm, or the lens opening. The *f*-stops are marked on a ring around the lens barrel close to the camera body. Numbers run from the widest aperture of the lens, such as *f*/1.7, to the smallest, which is usually *f*/16. The ratio of *f*-stop numbers to the

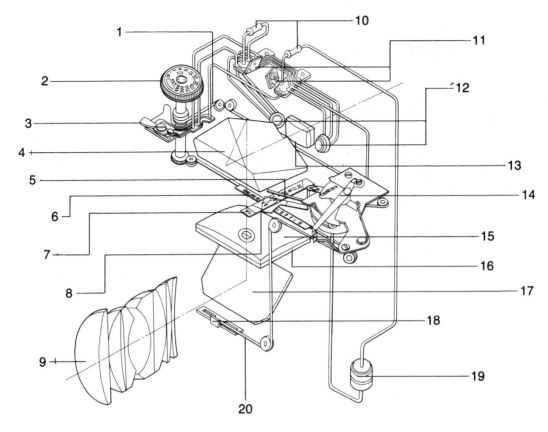

The Konica Autoreflex N-T3 metering system: 1. Shutter and film-speed coupling
2. Shutter and film-speed dial 3. Meter switch 4. Pentaprism 5. Meter needle
6. Shutter-speed scale 7. "Control Center" viewfinder 8. Identification mark of f-stop
at full lens opening 9. Hexanon lens 50 mm f/1.4 10. Compensating resistors
11. Variable resistors 12. Compound CdS cells 13. Eyepiece 14. Meter
15. Condenser lens 16. Focusing screen 17. Mirror 18. Lever for transfer of f-stop at
full lens opening 19. Mercury batteries 20. f-stop coupler

amount of light they admit to affect and control exposure is shown in the accompanying illustration. The smaller the f-number, the larger the lens opening. The f-numbers in large type designate full stops, the term used to describe primary lens openings. Numbers in small type are half-stops. As you close the diaphragm and f-numbers get larger, each stop offers *half* the exposure of the one before it.

Remove the lens from your Konica and look through it while clicking the diaphragm ring from one stop to another. You'll see how the opening changes, and you'll feel the clicks at the half-stops between the numbers inscribed on the ring. Going from one lens opening to a smaller one is called *stopping down*. The reverse, going from one lens opening to a larger or wider one, is called *opening up*. Though aperture selection is automatic with the N-T3 and an EE or AE lens, you should be familiar with the relationships between f-stops for good picture-taking techniques.

The Autoreflex N-T3 viewfinder: 1. Underexposure indicator for f/1.2 lens 2. Match-needle index mark for uncoupled lens 3. Shutter speed in use 4. "M" (manual) exposure indicator 5. Automatic maximum-aperture/underexposure indicator 6. Meter needle 7. Battery test indicator 8. Aperture scale 9. Overexposure indicator

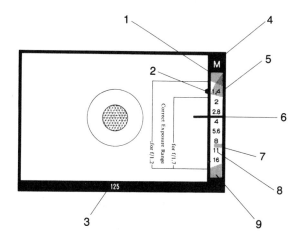

AUTOMATIC EXPOSURE CONTROL IN OPERATION

When you study the schematic diagram of the Konica N-T3 metering system, you are looking into the "vital organs" of this precision camera. Briefly, here's how the electromechanical components work:

1. When the meter switch is turned on, electric power flows from the batteries through wires and resistors to the CdS cells within the viewfinder dome.
2. The CdS cells measure the intensity of the light coming through the lens and being reflected by the mirror through the ground glass and pentaprism.
3. Tiny switches, gears, and more resistors transfer the CdS measurement into a correct lens opening, depending on the shutter speed selected.
4. At the right side of the viewfinder, a needle points to the f-number determined by the meter, which will be translated to the lens diaphragm.
5. When you change the shutter speed, seen at the bottom of the viewfinder, the meter needle is readjusted accordingly.
6. When the shutter release is depressed to take a picture, the f-stop coupler and other components close the iris diaphragm of the EE or AE lens to the opening indicated by the meter needle. The

needle may vary according to lighting conditions as you prepare to shoot, but it freezes into place a fraction of a second before exposure. The shutter curtain crosses the film plane another fraction of a second after the lens is stopped down to the proper setting.

7. After the exposure, the shutter curtain rests completely across the opening in front of the film, blocking all light. This explains why you can remove and replace a lens at any time without fogging your film. After exposure, the meter needle again shows you the correct f-stop for the light at hand, but the lens diaphragm returns to full opening, giving you the brightest image for viewing and focusing.

As this electromechanical magic takes place, the mirror snaps up and out of the way of the incoming image. As you shoot, you hear a compound click of mirror flipping up and down and shutter opening and closing. Both the shutter and the mirror in the Konica Autoreflex (all models) are quieted by sound- and vibration-absorbing materials.

In the preceding description is the key to Konica's automation: The auto-exposure system is making consistent and instant decisions each

time you depress the shutter-release button. Camera controls working properly and handled with understanding free you to concentrate on composition and pictorial content.

FILM-SPEED DIAL RATINGS

	<2500>	<2000>	<1250>	<1000>	<640>	<500>	<320>	<250>	<160>	<125>	<80>	<50>	<32>	<20>	<16>	
ASA	3200	·	· 1600	·	· 800	·	· 400	·	· 200	·	· 100	· 64	· 40	· 25	·	· 12
DIN	36	·	· 33	·	· 30	·	· 27	·	· 24	·	· 21	· 19	· 17	· 15	·	· 12
	<35>	<34>	<32>	<31>	<29>	<28>	<26>	<25>	<23>	<22>	<20>	<18>	<16>	<14>	<13>	

Note: The numbers in brackets are indicated by dots on the dial.

THE KONICA VIEWFINDER

Konica calls its camera finder the "control center," for it is equivalent to an instrument control panel that shows quickly and neatly how interior components are set. The finder is your "window on the world" as you photograph.

At the right is the f-stop needle, which varies according to the intensity of the light as sensed by the meter's CdS cells. Starting at the top, "M" appears to indicate the manual mode, discussed below.

The shaded area (a red band in the camera) above the f-stop numbers adjusts itself automatically to indicate the maximum aperture of the lens in use. The upper red area remains constant and applies only to the f/1.2 Hexanon lens. Underexposure will result if the needle swings into this upper area.

Overexposure is indicated when the needle moves into the bottom red area, except when you use a lens that stops down to f/32, such as the macro Hexanon. In bright light with a fast film loaded, the needle in the bottom area tells you to switch to a faster shutter speed.

The index mark opposite the f/1.4 setting is used with non-EE or AE lenses for stopped-down metering.

The red line between f/8 and f/11 is the battery-check mark described earlier.

The shutter speed in the bottom margin shows up best against medium or bright light and is hard to see in relative darkness.

The microdiaprism in the center of the finder consists of many tiny prismatic forms. With this spot, you precisely focus the lens. When an image is out of focus, the spot shows a muddled pattern that becomes crisp when sharp focus is attained. A slight turn of the lens may show the difference between in-focus and out-of-focus images, depending on the distance focused and the lens focal length.

The plain ground-glass circle around the center diaprism spot magnifies texture slightly when you focus on a patterned surface.

In some models of the Konica N-T3, there is also a split-image rangefinder focusing screen. When a subject is out of focus, the top and bottom halves of the rangefinder image do not meet precisely. You know the point on which you focus is *in* focus when the split-image spot is realigned to match halves perfectly. As mentioned before, split-image rangefinder focusing in the Konica N-T3 makes accurate focusing easier, and it does *not* interfere with your composition.

The Finder During Automatic Exposure

First program the meter by setting the film ASA speed. Do this by lifting and turning the outer collar around the shutter-speed dial until the correct numeral or dot is opposite the ASA or DIN index mark. A linear display of film speeds on the dial is shown in the accompanying illustration. Numbers in brackets show the values of dots between the engraved numbers. The outer collar clicks into place at each dot or numeral.

Then choose a shutter speed appropriate for the subject and light. Faster speeds help avoid camera movement.

Flip the meter switch to "on" manually or by advancing the film. Analyze the position of the meter needle. If it's in the top or bottom red zones, adjust the shutter speed to correct the exposure. If the needle won't move into the white area from the top red zone, the scene may require a time exposure. If the needle won't rise from the bottom red zone, try a neutral density filter to reduce film speed or switch to a slower film.

When you wish to shoot at a specific lens opening, revolve the shutter-speed dial until the meter needle points to the desired f-stop. If the indicated shutter speed is suitable, take your pictures!

Manual Exposure with EE or AE Lenses

There are times, such as when you shoot with electronic flash, when you need to set the aperture ring of a Hexanon lens to a specific f-stop. To do so, press the tiny lock button that appears on most EE and AE lenses and adjust the ring to the f-stop desired. This was done at a night graduation ceremony when the meter scale showed f/2 at 1/30 sec. (see the accompanying illustration). The black background was influencing the system towards overexposure; a lens setting of f/4 overrode the automation. Shadow detail in the negatives was decreased, but highlights were easy to print.

When you turn the lens-diaphragm ring off EE or AE, you see an "M" in the top right-hand corner of the viewfinder to remind you that the camera is in the manual mode. When conditions change and you wish to change back to the automatic mode, it is very easy to forget to reset the lens back to EE or AE. Since the meter needle indicates correct exposure in either the manual or automatic mode, you are lulled into assuming all is well. Therefore, make a habit of checking the "M" and the aperture ring of your lens to be sure it reads EE or AE if that's where you want it. Otherwise, overexposure or underexposure will result.

If you want an off-beat exposure, such as this one taken with a 135 mm Hexanon lens at 1/30 sec. and f/4, you must override the EE system.

Stopped-down Exposure Metering

Lenses with manual or preset diaphragms do not operate in the automatic mode, for they are not capable of connection to the system. In such a case, use the stopped-down technique as follows:

1. Set the correct film speed.
2. Select an appropriate shutter speed.
3. Turn on the camera metering system.
4. Revolve the lens-aperture ring until the meter needle lines up with the index mark opposite the f/1.4 on the finder scale. This indicates correct stopped-down exposure. Of course, you may also adjust the shutter-speed ring to bring the needle to the proper index mark. Stopped-down needle positions for underexposure and overexposure are included in accompanying illustration.

Stopped-down metering is also used with a lens adapter and lenses not made with the specific Konica mount, and with extension tubes or a bellows when the lens is separated from the camera body. If you shoot with a mirror reflex lens, which has a fixed aperture, bring the needle to the stopped-down index mark via the shutter-speed dial, or neutral density filters, or both.

Depth-of-field scale on a Hexanon lens (upper left). Depth of field is indicated as 8 feet to infinity at f/16 (bottom left). Depth of field is now 5 feet to 12½ feet at f/16 (above).

DEPTH OF FIELD

Depth of field is the distance, or area, between the *nearest* and *farthest* objects in a scene that will appear in acceptably sharp focus in a finished print or slide. Three factors combine to govern depth of field: (1) lens aperture, (2) lens focal length, and (3) focusing distance. Each factor is detailed in the following text.

Aperture

The smaller the lens opening, the greater the depth of field is in a photograph. Depth of field *increases* as the lens is stopped down.

Conversely, the larger the lens opening, the less the depth of field. Depth of field *decreases* as the lens diaphragm is opened up.

To demonstrate this depth-of-field principle, study the Hexanon lens barrel as focus is changed. Note first the identical series of aperture numbers on both sides of the center index mark (shown in the accompanying illustration). This is the depth-of-field scale, and it serves as a quick, approximate guide. Here's the depth-of-field story in a nutshell:

●Focused at infinity (∞), depth of field extends to about 15 feet from the camera at f/16 (the f-stop to watch in this exercise).

●Focused at 15 feet, depth of field is now approximately from 8 feet to infinity at f/16. Thus, the depth of field is shown for a given lens aperture between the f-number on the left and its twin on the right.

●Focused at 7 feet, depth of field is now from about 5 feet to 12½ feet at f/16.

Conduct your own depth-of-field exercises with several lenses for your N-T3 to become familiar with this phenomenon, which is not as mysterious as some people may feel. Keep in mind that these measurements are approximate, and more precise figures are charted in depth-of-field tables at the end of Chapter 5. Don't try to memorize such figures, but learn from them how depth of field is affected as you change lens apertures, and focusing distance or lens focal length.

Outdoors when you can shoot at f/11 or f/16, it is often expedient to pre-focus your lens in order to shoot in a hurry, knowing that a certain area will be sharp at a relatively small aperture. In crowds or while walking on a street, you then can make grab-shots and catch facial expressions or action, knowing depth of field is working for you.

Lens Focal Length

The focal length of a lens is defined as the distance from the center of the lens to the film plane, and it is usually given in millimeters.

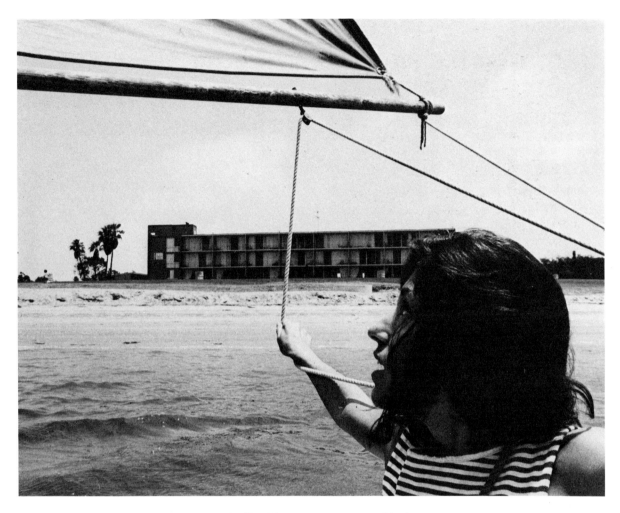

This is an example of extreme depth of field offered by a 28 mm Hexanon *f*/3.5 lens.

Again, there are optical absolutes that influence depth of field: At a given aperture and focusing distance, a short-focal-length lens produces greater depth of field than a longer one. Putting this another way, the longer the lens focal length, the less depth of field it provides at a given aperture and focusing distance.

In general, there are three lens categories (fully described in Chapter 5):

Short-focal-length lenses. Also called wide-angle lenses, short-focal-length lenses range from 15 mm through 35 mm. The accompanying illustration is a sample of how much depth of field you can expect from a 28 mm lens. The subject was only 2½ feet away in a small sail-boat, and the hotel in the background was at the infinity setting. With the lens focused at 5 feet, the area of sharp focus extended from 2½ feet to infinity at *f*/16. Had a longer-focal-length lens been used, one would have either had to move backwards (into San Diego Bay) or be satisfied with the subject in focus and the background (hotel) out of focus. A shorter-focal-length lens, such as a 21 mm, offers even more depth of field than a 28 mm, but additional distortion also occurs, as noted in Chapter 5.

Medium-focal-length lenses. These lenses range from 50 mm through 100 mm.

The self-timer lever pressed toward the lens gives depth-of-field preview on the Konica N-T3 model.

Long-focal-length lenses. Called telephoto lenses, long-focal-length lenses range from 135 mm through 300 mm and longer.

Focusing Distance

The closer you focus to a subject, the *less* depth of field any lens produces. In reverse, the farther your point of focus, the *greater* the depth of field. In addition, depth of field increases faster *behind* the point of focus than in front of it. Referring to the accompanying illustrations, when the lens is focused at 7 feet, depth of field ranges from 2 feet in front of the focal point to 5½ feet behind it. When the lens is focused at 15 feet, depth of field increases to 6½ feet in front of the focal point but extends to infinity behind it. With this principle in mind, you will often focus slightly in front of the main subject to increase depth of field closer to the camera, knowing that depth of field behind the focal point will be sufficient.

Depth-of-Field Preview

To predetermine depth of field before taking a picture, you may use the depth-of-field scale on the lens barrel as a guide, and you may also stop down the lens diaphragm by pressing the self-timer lever towards the lens. As long as you depress the lever, the lens will remain at the *f*-stop indicated by the meter needle. The viewfinder image darkens when you preview depth of field, due to the smaller aperture; and thus, the depth-of-field impression you get is approximate since the scene is miniaturized in the finder as well. Distinctions will be more noticeable when slides or negatives are enlarged. However, focus gradually shifts from sharp to fuzzy.

A typical depth-of-field problem is demonstrated in the accompanying illustration. Eleanor Bralver was seated in the stands with a 100 mm lens focused on third base about 40 feet away. Her exposure for Kodak Tri-X film was 1/500 sec. at *f*/16; by using the depth-of-field scale on the lens, she determined she could carry sharp focus from about 30 feet to infinity at *f*/16. She prefocused the lens accordingly and waited for this exciting action, knowing she would have both players and crowd in sharp focus on the film. Many other picture situations lend themselves to preset focus in the same way.

Depth-of-field preview through a wide-angle lens is more difficult to see than through a normal or telephoto lens, because the wide-angle has greater inherent depth of field, and

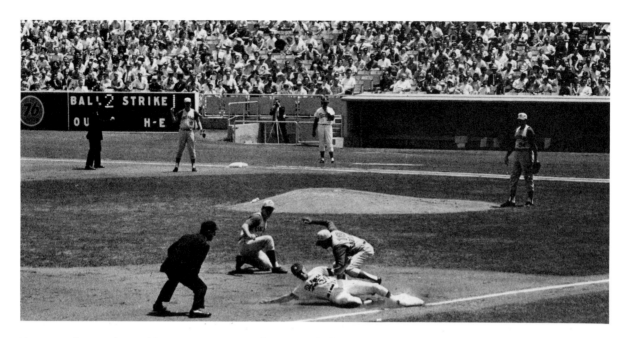

Eleanor Bralver prefocused her 100 mm Hexanon lens to catch this exciting action at 1/500 sec. at *f*/16.

distinguishing between sharp and out-of-focus areas is less exact. However, the same optical characteristics give you more margin for error when you preview or use the depth-of-field scale.

To repeat a warning in the Konica N-T3 instruction booklet: Do *not* depress the small button in the center of the self-timer when using the lever for depth-of-field preview. Mechanical damage to camera may occur.

SELF-TIMER

The self-timer on a Konica Autoreflex N-T3 is helpful in several ways. To use it, follow these steps:

1. When the shutter is cocked, depress the small button at the bottom of the self-timer and revolve the lever *away* from the lens about 90 degrees.
2. Now when the shutter-release button is depressed, the timer lever begins to rise, making a faint buzz as a time signal to you.
3. In the 10–12 seconds it takes the self-timer to return to vertical position and fire the shutter, you can do one or more of the following:

The self-timer is activated by pressing the small button first.

33

a. With the camera on a tripod or firm base, you can hurry and get into the picture with a group, or in a scene serving as your own model.

b. Any time you wish to minimize camera movement, e.g., hand-holding your Konica at a slow shutter speed, use the self-timer. Cock it partway to decrease delay to 4 or 5 seconds.

c. With your camera on a tripod and your hands otherwise occupied, shoot with the self-timer. The accompanying illustration and others, in which one hand appears and the other is holding a reflector, were taken with the self-timer, which became the unpaid "assistant."

d. When shooting close-ups where the slightest camera shake will be magnified in an image which is enlarged, use the self-timer instead of a cable release.

EYEPIECE SHUTTER

While you shoot with a camera that includes a built-in automatic exposure meter, it is advisable to keep your eye close to the finder eyepiece. This prevents extraneous light from "coming in the back door" to influence the metering operation. Therefore, for those occasions when you can be away from the camera (which is activated by the self-timer), there is an

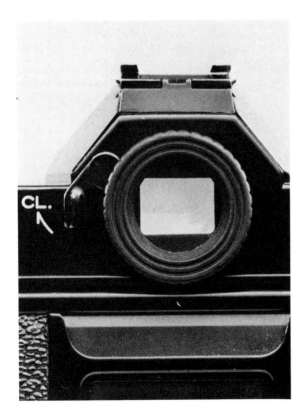

The eyepiece is uncovered when the shutter lever is down.

The eyepiece shutter covers the finder when the lever is up.

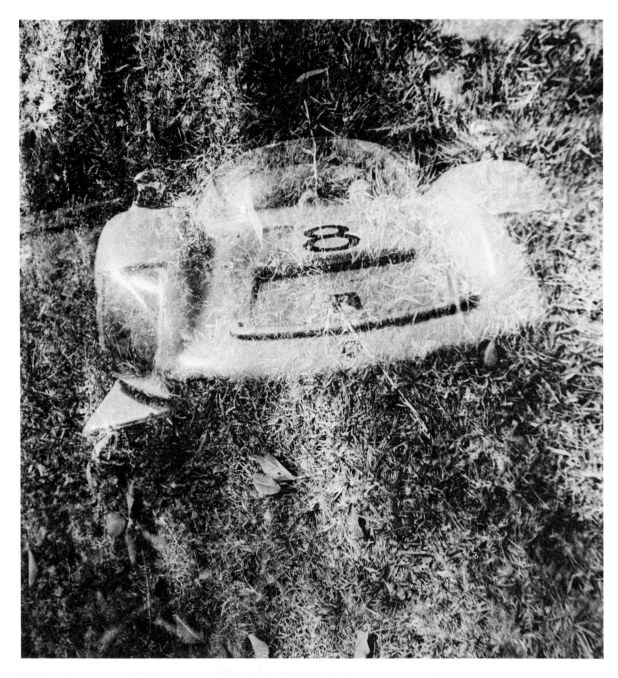

This is an intentional double exposure with the Konica N-T3 by Barry Jacobs, who gave this small race-car model an air of mystery by superimposing grass on it.

eyepiece shutter on the Konica N-T3 to assure proper exposure. In the accompanying illustration, the eyepiece is uncovered and you see light coming through the lens, which means light may also travel through the finder to register on the CdS cells. When the shutter lever is flipped up, the eyepiece goes dark, simulating your eye in place blocking the light.

A person who wears glasses cannot press his or her eye directly against the finder; however, there is no evidence of light leakage in such cases.

MULTIPLE-EXPOSURE LEVER

A particularly welcome feature of the Konica N-T3 is the multiple-exposure lever located at the bottom left of the shutter-speed dial. Without such a device, it is frustrating to make intentional double exposures for their creative impact, because you cannot be sure of image registry. This means that one exposed image may not appear precisely in the same frame space as another; and when there's even a slight image shift (known as being off-register), most color film processors will not mount slides because they don't know where to trim the film between frames.

With the Konica N-T3 these worries don't exist. To shoot multiple-exposure special effects, simply take a picture (according to the following suggestions), advance the film while pressing the multiple-exposure lever in the direction of the arrow, and take another shot. The shutter will be cocked, but neither the film nor the frame counter will move. You can do this several times in succession with proper exposure practice. Following are directions.

For a double exposure, divide the normal exposure for a scene by two, and for a triple exposure, divide by three. You can do this by adjusting the film's ASA setting. For instance, if your film's normal ASA setting is 125, double it to 250 for a double exposure, which divides the correct exposure by two. In other words, instead of 1/125 sec. at $f/8$, the camera will indicate 1/125 sec. at $f/11$, and two such exposures at $f/11$ are equivalent to one at $f/8$. For a triple exposure, double the ASA again to 500.

In planning multiple-exposure compositions, keep in mind that light areas such as sand or sky tend to overpower or wash out darker areas, so separate the areas or combine them consciously. Anticipating how colors will blend is only approximate, but serendipity is part of the fun of shooting multiple exposures.

Avoid the normal reflex of advancing the film immediately, and remember to press the multiple-exposure lever as you cock shutter.

When you finish shooting multiple exposures, remember to turn the ASA rating back to normal. Of course, you can achieve the same variations of exposure by manually adjusting shutter speeds and f-stops with your N-T3 and not touching the film-speed setting at all.

The accompanying illustration is another example of a double exposure combining a small model racing car with a close-up of leaves and grass to create an air of mystery. If you haven't experimented with possible effects using the multiple-exposure lever, you're in for some photographic adventures. Care and craftsmanship are the keys to creativity.

ADDITIONAL FEATURES

Shutter-ready Indicator

Beside the shutter-speed dial, there is a round dot next to the multiple-exposure lever that tells you quickly if the camera shutter is cocked or not. If the dot is green, you're ready to shoot, and if it's red, you must advance the film and cock the shutter before taking a picture. This dot signal saves you trying to advance the film, wasting time, and putting unnecessary strain on the lever.

Changing Lenses

To remove a lens from your Konica N-T3, grip the lens securely and, while pressing the lens-lock-release button, turn the lens counterclockwise until the red dot on the lens lines up

The memory-lock feature of the Konica Autoreflex helped set the metering system for the correct exposure in this shot taken with a 100 mm Hexanon lens.

with the red dot on the camera body. Lift the lens out.

To mount a lens, line up the red dots on lens and body, gently seat the lens into the body, and turn the lens clockwise until it clicks into place. Be careful to seat the lens completely or you may damage the lens and the body flange. This is particularly important with telephoto and zoom lenses, because you have a lot of leverage as you turn the lens, and you must do it gently to avoid problems.

Film-type Tab Holder

You can slide the end tab from a 35 mm film carton into the square slot on the back of your Konica N-T3. This reminds you immediately what's inside the camera. If you use the same kind of film all the time, leave the slot empty or use it to write yourself notes!

Shutter "Memory" Lock

The first few millimeters that you depress the shutter release of a Konica N-T3 serve to freeze the meter needle at the indicated exposure setting. Until you lift your finger from the button, or depress it completely to shoot a picture, the meter will "remember" just the *f*-stop indicated. It's easy to hold the shutter-release button in a half-depressed state because your finger rests on a collar—the same collar you revolve to turn the meter on and off.

The "memory" lock comes in handy when you shoot in contrasty lighting, such as backlighting, or when there's a bright object in front of a dark background. You simply move the camera to within inches of the main subject, and partly depress the shutter release to freeze the meter needle. Then return to a more distant spot and shoot your picture. You can also lock the meter by depressing the self-timer lever toward the lens. In the accompanying illustration, the sidelight was too bright and would have overly influenced the portrait exposure; a close-up reading assured an average exposure.

Infrared Distance Index Mark

When shooting with infrared film and the correct filter, focus the lens as usual. Then move the correct distance figure opposite the center index mark over to line up with the index line opposite the red "R" on the lens barrel. This is the infrared compensation mark; since infrared rays focus on a slightly different plane than do light rays in the visible spectrum.

Focal-plane Mark

On top of the Konica to the left of the prism dome is a small circle with a straight line

The lens-lock release button is pressed to remove a lens.

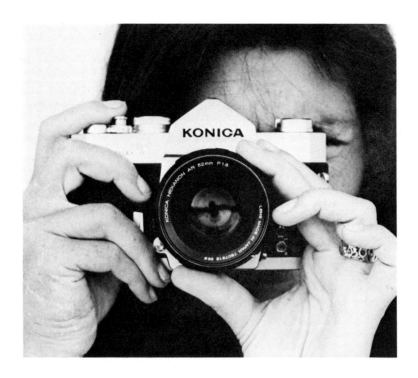

When you hold the Autoreflex in a horizontal position, use the right hand to grip the body firmly and the right index finger to depress the shutter; use the left hand to focus (above left). One way to hold the camera for vertical shots is to place the right hand under the camera and use the left hand to focus (below left). Another vertical position is to turn the camera 180 degrees so that the right hand is on the top of the camera and the left hand is on the lens barrel (below right).

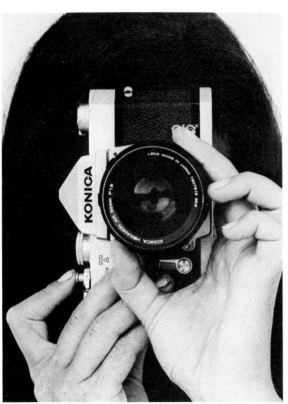

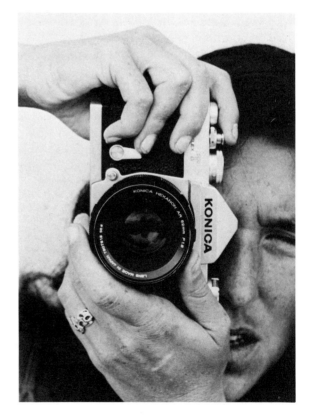

through it. That line indicates the position of the film in the camera in case you have to measure precisely from film to subject for close-ups.

Flash

Use the hot shoe or one of the flash terminals at the end of the camera to attach a flash unit to your N-T3. Full details about flash techniques and equipment are covered in Chapter 7.

Holding the Camera

Most people are right-eyed and hold the camera horizontally as seen in the accompanying illustration. Grip the body firmly with the right hand and gently depress the shutter-release button with the right index finger. In this or any position, be careful not to jerk the camera as you shoot. Squeeze the shutter release, a practice you will perfect with experience, even when shooting quickly.

In a vertical position, there are two ways to hold your Konica. One way is to position the right hand under the camera with the right index finger on the shutter release and the left hand focusing. For the other method, the camera is revolved 180 degrees; the right hand is on top, and the left hand turns the lens barrel. In either vertical position, you must move the camera away from your face to advance the film. (In the horizontal position, you should be able to turn the film-transport lever without moving the camera very far from your eye.)

Scratches on Film

Sometimes you have to be a detective to discover the source of scratches on film, but the first place to look is in the film cartridge. If you load your own film, used cartridges or the film loader may be causing scratches. A tiny speck of dust on a brand-new cartridge can also be the culprit.

Inside the camera, tiny imperfections in the surface of the pressure plate that rests against the back of the film can cause scratches. This plate is easily replaceable, and it may be the

cause of such scratches found in the film base (back) and not in the emulsion.

Scratches on the emulsion side of the film may come from rubbing against a film take-up spool, but only when the spool becomes old and worn. The film rides along two silver tracks on each side of the body opening, and none of the picture area should ever touch any part of the camera.

Camera Care

You may know how to fix an automobile or service a computer, but only a professional camera repairman is qualified to treat a malfunctioning camera. If something goes wrong, keep your miniature screwdrivers away from your Konica, unless you have the training to do it yourself. For preventative maintenance, here are a few pointers:

1. Don't touch the mirror with your fingers; brush it with a soft brush.
2. Keep the interior and exterior of your camera clean by dusting regularly with a soft brush. A piece of damp facial tissue is safe on exterior metal and leather.
3. Lens-cleaning fluid and tissue may be used sparingly when needed. Don't use a handkerchief or facial tissue on a lens.
4. Keep your Konica dry, safe from sand, dust, and salt spray, and secure from bumps and falls. This advice may sound obvious, but you'd be surprised to hear the camera-abuse stories that repairmen tell.

Most Konicas have shown none of the following hangups, but some other camera brands have, so the symptoms are listed just in case:

1. If the film transport won't turn, don't force it. There may be dirt or sand in the gears, or a tiny bit of film may have filtered into the vital organs. For this and

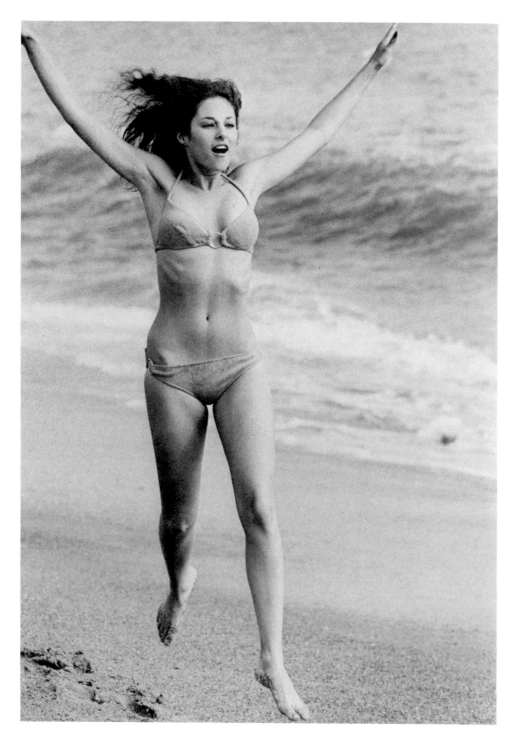

The model was frozen in midair using a 1/1000 sec. shutter speed on a Konica T3 with the 65–135 mm Hexanon zoom lens. At the beach you must guard against sand and salt spray that will damage a camera.

the other remaining items, see a camera repairman.

2. If your shutter slows down, it vignettes the image, which means one portion may have correct exposure, and the rest is dim or blank. Shutter-speed springs may suffer fatigue; overexposure is one symptom.

3. The iris diaphragm of a lens may malfunction causing iris bounce, which means the iris diaphragm stays open too long though the lens seems to be working well. Again, overexposure is the problem you face.

4. Dropped or drowned cameras may result in all sorts of damage requiring professional help. Should you drop a Konica, check the finder, the shutter speeds, the mirror return, and the meter-needle function, as well as the tightness of the back cover and lens mount. You may have a light leak and not know it until you have the film processed. As for a drowned camera, drain it and allow it to dry, but get it to a repairman as soon as possible because interior parts can rust. A camera dropped in saltwater should be immediately dunked in freshwater to rinse it and then "hung out to dry," but a few prayers wouldn't hurt either.

Your Konica Autoreflex N-T3 is a hearty instrument that resists everyday handling and stays reliable night and day. Treat it right and it will age gracefully, providing you with countless fine photographs as it does.

Features of the Konica TC

In the spring of 1976, the Konica Autoreflex line was blessed with a "little brother," the TC model, which is lighter and more compact in size than the N-T3, and available at a lower cost. However, the new model is completely *compatible* with the line, because it accepts all Hexanon lenses and all accessories in the Konica Autoreflex system. The TC offers fully automatic exposure, which functions in the same manner as described for the N-T3.

It is therefore not surprising that the Konica TC has become an ideal first camera for newcomers to SLR photography, as well as a welcome second or third camera for owners of the N-T3 and previous Autoreflex models. Since the TC is approximately 25 percent smaller and lighter than the N-T3, it costs less, but it does a major portion of the same jobs expected of "big brother." Thus, the TC is a neat addition to the integrated Konica family.

Size comparison between the Konica TC (left) and the N-T3 (right).

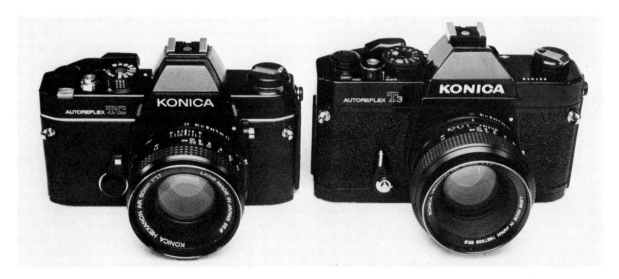

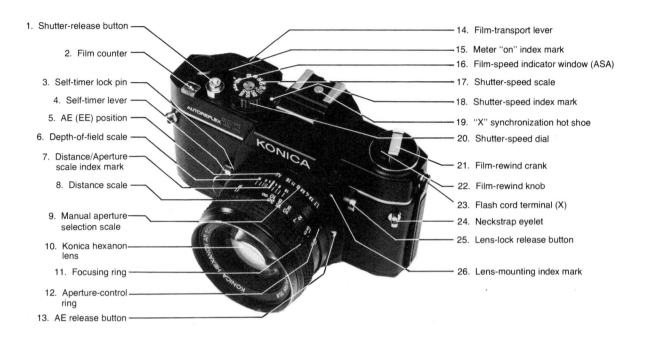

1. Shutter-release button
2. Film counter
3. Self-timer lock pin
4. Self-timer lever
5. AE (EE) position
6. Depth-of-field scale
7. Distance/Aperture scale index mark
8. Distance scale
9. Manual aperture selection scale
10. Konica hexanon lens
11. Focusing ring
12. Aperture-control ring
13. AE release button

14. Film-transport lever
15. Meter "on" index mark
16. Film-speed indicator window (ASA)
17. Shutter-speed scale
18. Shutter-speed index mark
19. "X" synchronization hot shoe
20. Shutter-speed dial
21. Film-rewind crank
22. Film-rewind knob
23. Flash cord terminal (X)
24. Neckstrap eyelet
25. Lens-lock release button
26. Lens-mounting index mark

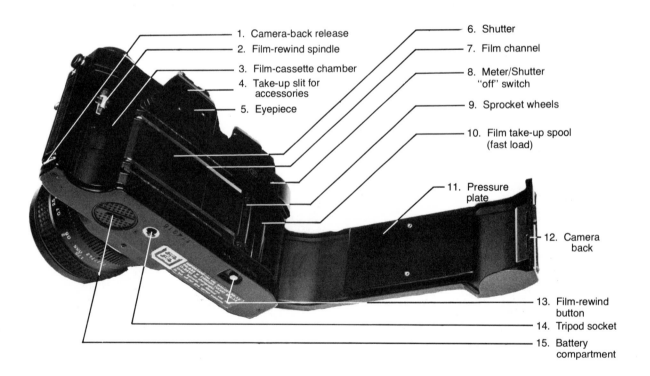

1. Camera-back release
2. Film-rewind spindle
3. Film-cassette chamber
4. Take-up slit for accessories
5. Eyepiece

6. Shutter
7. Film channel
8. Meter/Shutter "off" switch
9. Sprocket wheels
10. Film take-up spool (fast load)
11. Pressure plate
12. Camera back
13. Film-rewind button
14. Tripod socket
15. Battery compartment

Operating controls of the Konica Autoreflex TC.

GENERAL FEATURES

Many features and operations of the Konica TC that are identical to those of the N-T3 will be listed later without describing them in detail. Before you continue here, however, read the owner's manual, the excellent booklet that comes with your camera. The following particulars about the Konica TC will augment that information, with repetition merely for the sake of clarity. Follow the suggestion on page 2 of the TC booklet to shoot a test roll of film, but while you test the camera's operations, first do so without film in the camera. You'll be less inhibited about trying things until they are comfortable.

Specifications

Because most specifications for the Konica TC are the same as those listed for the Konica N-T3 in the previous chapter, please refer to that section as well as to the specs below which are specific to the Konica TC.

Shutter speeds. 1/8 sec. through 1/1000 sec., plus "B" for time exposures.

ASA range. 25–1600.

Meter power source. Two 1.35-volt mercury batteries, Mallory PX-13, PX-625, Eveready EPX-625, or the equivalent. These are the same voltage *but not the same batteries* used in the Konica N-T3.

Meter EV range. With ASA 100 film and f/1.7 lens, EV 4.5 (1/8 sec. at f/1.7) to EV 18 (1/1000 sec. at f/16). With f/1.2 lens, EV 3.5 to 18.

Focusing screen. Three-way system with split-image rangefinder plus microdiaprism and fine ground-glass focusing.

On/off switch-lever. When the film-advance lever is pulled away to the intermediate stop position from the camera body, the meter is turned on and the shutter release is unlocked. The advance lever springs back flush with the body when the "off" switch is pressed.

Dimensions. Body only: height 3.5", width 5.4", depth 1.8". *With new 50 mm f/1.7 lens:* 3.5" × 5.4" × 3.3". *Weight, body only:* 18 oz. *With new 50 mm f/1.7 lens:* 25.4 oz.

OPERATING FEATURES OF THE KONICA TC

In many respects, the TC and the N-T3 are alike, including vertical-travel, metal focal-plane shutter, hot shoe, aperture readout in the finder, self-timer, and so forth. All the operating features and controls of the Konica Autoreflex TC are labeled in the accompanying illustrations. To avoid repetition, for information about the following operations and features, in addition to data found in the camera's instruction booklet, please refer to these headings for the Konica N-T3 in Chapter 2:

Inserting Batteries
Loading the Camera (important material to avoid "false" loads)
Film Advance and Rewind (never force any levers)
Rewinding Film in Mid-roll
Shutter and Aperture (additional TC details below)

Automatic Exposure Control in Operation
The Konica Viewfinder (Specifics for the TC follow, and more details are included in the N-T3 material.)
Stopped-down Exposure Metering
Depth of Field (optical principles that apply to all cameras)
Infrared Distance Index Mark
Holding the Camera
Camera Care (sensible ways to reinforce your camera's reliability).

When you have read about the features listed above, you will find differences between the TC and the N-T3. The N-T3 model has these additional features:

Shutter-speed readout in the finder
Shutter speeds slower than 1/8 sec.
Depth-of-field preview lever

Battery-check circuit
Multiple-exposure lever
Eyepiece shutter

In return for those features not included in the TC, note the reduction of size compared to the N-T3 (see the illustration on p. 43), and check the dimensions and weight of the two cameras. There's a half pound less to carry when you use the TC, and that can be a welcome plus factor.

A New 50 mm *f*/1.7 Lens

To introduce the distinctions and features of the Konica TC, it's a pleasure to describe the new compact 50 mm *f*/1.7 lens designed especially for the TC but useful with any Autoreflex model, past or present. The new 50 mm *f*/1.7 lens projects ¼-inch less from the camera body than the larger standard lens and weighs 1½ oz. less, yet it has comparative sharpness and versatility and will focus to 21.6 inches from the film plane without accessory attachments. In addition, the front element of the new lens is indented so that no add-on lens hood is required. The focusing ring is clad in diamond-textured material for easy gripping, and of course, the new 50 mm lens works beautifully in the AE mode, or it can be unlocked for manual *f*-stop setting.

The lens-lock-release button on the Konica TC is located higher than on the N-T3 but works in the same way to release the lens latch when a lens is detached from the body.

A new 50 mm *f*/1.7 lens for the TC is smaller and lighter than previous normal lenses.

The TC lens-lock button is higher than that of the N-T3.

Batteries

As mentioned in the specifications, the TC takes a different battery number than the N-T3, though they look alike and are the same voltage. Don't try to interchange camera batteries—you'll get false meter readings.

Since the TC has no battery-check device, it's a good idea to mark on a piece of cloth tape the date you insert fresh batteries and attach this to the bottom of the camera. There you will notice the date fairly often, and when 9 to 12 months have passed (depending on how often you shoot pictures), replace the batteries routinely. For a few dollars, you are consistently guaranteed a full-powered camera.

Film Rewinding

You press the rewind button on the bottom of the camera and rewind in the manner described for the N-T3. However, unlike the rewind button on the N-T3, which tends to pop out if the shutter is half-cocked, the rewind button on the TC stays down if the shutter is not fully cocked.

Meter-Shutter On/Off Control

When the film-advance lever is flush with the TC camera body, the built-in metering is turned off, and the shutter release is locked against accidental exposure. To turn the meter on and free the shutter-release button for use, simply move the film-transport lever out to the "ready" position shown in the accompanying illustration.

As long as you're shooting, the film-advance lever returns to the "ready" position each time you use the lever, which is neatly accessible for efficient operation. It is never in your way unless you try to use the camera with your left eye, an awkward situation with *any* SLR. To turn the metering system off and save battery drain, merely touch the small "off" switch located just where your thumb would normally be at the top rear of the camera (shown in the accompanying illustration). Im-

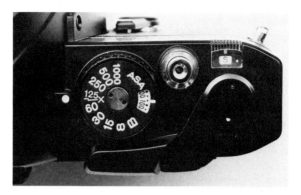

When the film-advance lever of the TC (and the T4) is flush with the camera body, the meter is off and the shutter release is locked.

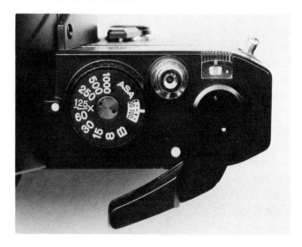

When the film-advance lever of the TC (and the T4) is flipped out to the "ready" position, the meter is on and the shutter is unlocked.

The convenient "off" switch on the TC (and the T4) snaps the film-advance lever to a flush, shutter-locked position.

47

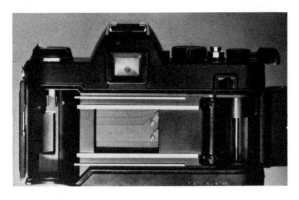

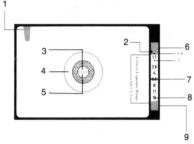

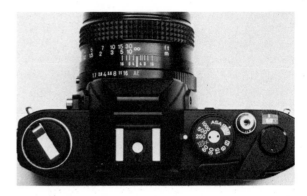

The metal shutter of the TC permits use of electronic flash at 1/125 sec. (above left). Top controls of Konica Autoreflex TC (above).

(Left) Information shown in the finder of the Konica TC: 1. Manual operation signal 2. Match-needle index mark (for stop-down metering with uncoupled lenses/ accessories) 3. Split-image rangefinder spot 4. Fine ground-glass ring 5. Microdiaprism circle 6. Underexposure indicator 7. Meter needle 8. Aperture scale 9. Overexposure indicator

mediately, the film-advance lever snaps back flush with the camera body, the meter turns off, the meter needle flips into the top red zone of the *f*-stop display, and the shutter-release button is locked. This new design for the TC is smooth and a joy to use.

Shutter Speeds and Meter Range

There is an informative "portrait" inside the back of the Konica TC. It shows very well the Konica's durable metal shutter, which operates vertically to "scan" the film plane in just 7.5 milliseconds, a speed not exceeded by any other shutter type. This feature provides synchronization with electronic flash units at all speeds up through 1/125 sec.

The controls on the top of the Konica TC are very handy. The rewind crank is easy to manipulate; the hot shoe incorporates a safety circuit breaker so it's only "hot" when a flash unit is inserted; shutter speeds are easy to see as are the film-counter numerals; and the shutter-release button is silky-smooth in use. There are click stops on the shutter-speed dial at each numbered speed, but you cannot set it for intermediate speeds between clicks. As with the

N-T3, the film speed is set by lifting and turning the collar around the shutter-speed dial.

The exposure-meter range of the Konica TC is shown in the accompanying illustration. The meter is sensitive enough to make light measurements in dimly-lit interiors, as well as in outdoor situations. However, as you can see, the metering system is not designed to couple for automatic exposure using slower shutter speeds with higher ASA films. When the light is not suitable for AE operation at a slow shutter speed, the system turns the meter off, and the meter needle moves into the upper red zone. To solve this, turn the shutter-speed dial to a faster speed until the meter needle moves into the white area. If the needle still fails to register, it may be expedient to switch to flash or flood-lighting, or to guess exposure on the "B" setting. Like the N-T3, the Konica TC functions at all shutters speeds even if the batteries are exhausted, although the meter does not work when power is lost.

Time exposures are made with the shutter-speed dial in the "B" position. As long as you hold the release button down, the shutter stays open. It is safe to do this with your finger for

EXPOSURE METERING RANGE OF KONICA TC:

ASA Film Speed	1/8	1/15	1/30	1/60	1/125	1/250	1/500	1/1000
25 200	○	○	○	○	○	○	○	○
250 400		○	○	○	○	○	○	○
500 800			○	○	○	○	○	○
1000 1600				○	○	○	○	○

○ Within range Out of range

several seconds when the camera is on a tripod, but use of a cable release is preferable. One with a locking mechanism is handy to avoid any possible camera shake. Time exposures on a firm base or tripod are usually adventures in photography.

The Konica TC Finder

In the TC finder, the upper red underexposure band and the lower red overexposure band are similar to those of the N-T3. The pointer signal at the top left flips into position when you shift a lens from EE or AE to manual operation. You may wish to override the TC automation and set f-stops manually with electronic flash, for instance, or you can adjust exposure manually when you are not satisfied with the setting indicated by the meter. Press the lens-release button, set the desired f-stop, compose, and shoot. The red pointer in the upper left of the finder faithfully reminds you to switch back to automatic when you're finished working in the manual mode.

The split-image rangefinder spot is built into all TC cameras, along with the microdiaprism grid and the fine ground-glass ring. Using one or more of these focusing aids assures precise focus with relative ease. You need not refer to the split image if you're in a hurry, but it's there for use with wide-angle lenses, or when you want to insure sharpness.

As described in Chapter 2, the "memory lock" feature of the TC allows you to hold a specific f-stop in the automatic mode. Press the shutter release part way and the meter needle locks, holding the indicated f-stop until you shoot or lift your finger.

Self-timer

Like the self-timer on the N-T3, this handy lever gives you from 4 to 10 seconds delay, time enough to get into the picture after you activate the shutter. You may also use the self-timer to make an exposure when your hands are otherwise occupied, or when you're shooting close-ups and wish to avoid potential camera shake.

To start the self-timer, move it away from the lens. When you press the shutter-release button, the self timer begins to buzz slowly to a vertical position where it will trip the shutter. When not in use, the self-timer should be latched on its lock-pin.

ET CETERA

If you wonder what "TC" stands for, there are several explanations. "T" continues the designation for the current model line, and "C" stands for "compact," which really does describe the lightweight Konica TC. In addition, a promotional brochure uses the phrase "Total

A 35 mm Hexanon lens caught this late-afternoon scene on Plus-X film.

Convenience" as a catchline for the TC model, which has so many assets without the weight and bulk.

If you own a Konica TC, you already know the delight of taking pictures with it. It operates smoothly and fits snugly in your hands. If you don't yet own a Konica TC, keep in mind that this "little brother" does almost everything the larger, more expensive N-T3 does, including accepting all the fine Hexanon lenses from 15 mm to 1000 mm. You may also use any Konica accessory with the TC, such as the Auto Bellows, the Slide Copier, or extension rings. Thus, the TC combines ease of handling with fully sophisticated operation, the hallmark of Konica's automatic exposure system.

The self-timer of the Konica TC can be set from 4 to 10 seconds.

Features of the Konica T4 and Auto Winder

Readers who own or anticipate buying the latest Konica Autoreflex T4 may have turned first to this chapter. The exciting T4 represents a new Konica generation, combining the compact, lightweight configuration of the TC model with the best features of the larger N-T3. In addition, the T4 is designed to accept the new Konica Auto Winder, a mini motor drive that attaches in seconds to the bottom of the T4 and gives the camera added value for action, portraits, and many other photographic subjects. With the Auto Winder, you also get Konica's proven shutter-preferred automation, whether you shoot 1.8 frames per second or more slowly. All Hexanon lenses and Konica accessories mount easily to the T4, and even with the Auto Winder in place, the T4 weighs no more than some higher-priced SLR's *without* an auto winder.

GENERAL FEATURES

First you'll recognize the Konica T4 by its reduced size and by the new "Konica" logo on the front. It somewhat resembles the TC, but the "T4" stands out in red. Check the shutter-speed dial and discover it runs from 1 sec. through 1/1000 sec., plus "B". Look beside the film-rewind knob for the battery-check button that flicks on a red signal light to indicate battery condition. And on the bottom plate, you'll see the auto winder coupling and terminals (electrical contacts) not found on any other Konica model.

Specifications

To avoid repetition here, please read the basic specifications for the N-T3 in Chapter 2.

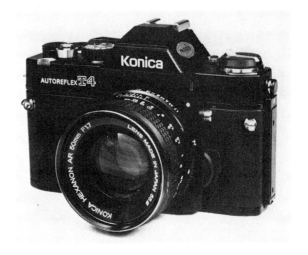

The new, lightweight, Konica Autoreflex T4 is designed for use with its own Auto Winder.

They are reviewed briefly here to point out distinctions and similarities between the T4 and the N-T3.

Shutter. The T4 incorporates the same vertical-travel metal focal-plane "Copal-Square" shutter found in the N-T3 and TC, including multiple-exposure device. Shutter-lock and on/off switch are both located on the back of the camera.

Meter EV range. EV 1.5 with ASA 100 film (f/16 at 1/1000 sec.).

Flash sync. Identical to the N-T3 and TC, up to 1/125 sec. Hot shoe and separate PC contact.

Self-timer. Variable 4 to 12 seconds.

Meter power source. Two 1.35-volt Mallory PX-13, PX-625, or Eveready EPX-625 batteries.

Exposure control system. Konica shutter-preferred with two CdS cells and variable metering.

Multiple-exposure control. Same as in the N-T3; you can cock the shutter without winding the film or advancing the exposure counter.

Film-transport lever. Swings out 21° when meter is on; full cocking action covers 139°.

Depth-of-field preview lever. Operates differently than on the N-T3; discussed below.

Finder. Has split-image rangefinder, plus microdiaprism and fine ground-glass focusing; shutter speed is not indicated.

Dimensions. Body only: height 3.6", width 5.4", depth 1.8". *With 50 mm f/1.7 lens:* 3.6" × 5.4" × 3.3". *Weight, body only:* 19 oz. *With 50 mm f/1.7 lens:* 26 oz.

OPERATING FEATURES OF THE KONICA T4

Basic operations of the Konica T4 are covered in the instruction booklet that comes with the camera. All operating features and controls are labeled in the accompanying illustrations. To avoid repetition, the following steps are listed; refer to more detailed descriptions of each in Chapter 2.

1. Insert batteries plus-side up.
2. Load the camera, making certain that the film is securely latched into the take-up spool; the rewind knob should turn as you advance the film.
3. Advance the film until the counter reads "1."
4. Set the correct ASA speed on the dial. Insert the end tab from the film box into the film-tab holder on the camera back as a reminder.
5. Focus, compose, and note the *f*-stop indicated by the needle in the finder. Adjust the shutter-speed dial according to subject movement and light level, using speeds of 1/125 sec. or faster when possible if the camera is hand-held.
6. Hold the T4 as described in Chapter 2.

The following features have been explained in Chapters 2 or 3, and if you wish to refer to specifics for the T4, please turn back to these sections:

Stopped-down Exposure Metering
Infrared Distance Index Mark
Depth of Field
Self-timer
Rewinding Film in Mid-roll
Shutter and Aperture (their relation to each other in terms of photographic technique)
Automatic Exposure Control in Operation
Camera Care
A New 50 mm *f*/1.7 Lens (described in Chapter 3, available as normal lens for Konica T4).

In previous chapters, there are many practical suggestions and instructions for using any Konica Autoreflex most effectively, and it is useful to become familiar with that material in relation to the new T4 model. The following examines some of the features *unique* to the T4.

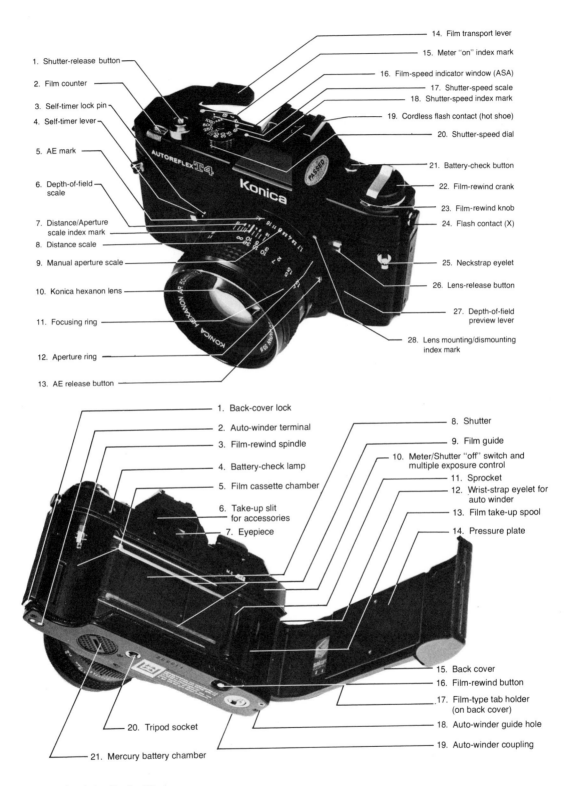

1. Shutter-release button
2. Film counter
3. Self-timer lock pin
4. Self-timer lever
5. AE mark
6. Depth-of-field scale
7. Distance/Aperture scale index mark
8. Distance scale
9. Manual aperture scale
10. Konica hexanon lens
11. Focusing ring
12. Aperture ring
13. AE release button

14. Film transport lever
15. Meter "on" index mark
16. Film-speed indicator window (ASA)
17. Shutter-speed scale
18. Shutter-speed index mark
19. Cordless flash contact (hot shoe)
20. Shutter-speed dial
21. Battery-check button
22. Film-rewind crank
23. Film-rewind knob
24. Flash contact (X)
25. Neckstrap eyelet
26. Lens-release button
27. Depth-of-field preview lever
28. Lens mounting/dismounting index mark

1. Back-cover lock
2. Auto-winder terminal
3. Film-rewind spindle
4. Battery-check lamp
5. Film cassette chamber
6. Take-up slit for accessories
7. Eyepiece

8. Shutter
9. Film guide
10. Meter/Shutter "off" switch and multiple exposure control
11. Sprocket
12. Wrist-strap eyelet for auto winder
13. Film take-up spool
14. Pressure plate

20. Tripod socket
21. Mercury battery chamber

15. Back cover
16. Film-rewind button
17. Film-type tab holder (on back cover)
18. Auto-winder guide hole
19. Auto-winder coupling

Operating controls of the Konica T4.

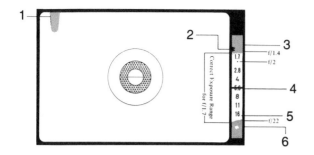

Information in the finder of the Konica T4, including split-field and microdiaprism focusing aids: 1. Manual aperture indicator mark 2. Index point for stopped-down metering 3. Automatic underexposure indicator 4. Meter needle 5. Aperture scale 6. Overexposure indicator

The Konica T4 Viewfinder

The accompanying illustration shows the functional, uncluttered T4 viewfinder, which offers a 40 percent brighter image because the interior of the pentaprism is silvered. The upper-right red zone indicates underexposure when the needle rests there (and the meter is on), while the lower red zone indicates overexposure. The black dot above the f/1.7 represents f/1.4, and the white dot below f/16 is for f/22, which is available on such lenses as the 55 mm macro Hexanon and, obviously, new Konica lenses to come. When the lens on your T4 is set in the manual mode (on a specific f-stop rather than AE), the red pointer shown at the top left pops into place. This reminds you that the camera's automatic exposure system is *not* in operation; and this is especially handy in rela-

tion to using the depth-of-field preview described later. Note, even when you are in the manual (non-AE) mode the Konica's meter needle continues to show the correct aperture for the shutter speed and scene.

There are three focusing aids in the T4 finder, beginning with the center split-image rangefinder for most accurate focus. Reference to the surrounding microdiaprism grid and the fine ground-glass ring can be quick and adequate, so focusing becomes an automatic reaction.

As described in Chapter 2, the "memory-lock" feature allows you to maintain a specific f-stop by pressing the shutter-release button halfway down and holding it there. The meter needle locks at the indicated setting until you shoot or lift your finger, a technique very useful for backlighting.

EXPOSURE METERING RANGE OF KONICA T4

ASA Film Speed		1	1/2	1/4	1/8	1/15	1/30	1/60	1/125	1/250	1/500	1/1000
25 . .	32	O	O	O	O	O	O	O	O	O		
40 . .	64	O	O	O	O	O	O	O	O	O	O	
80 . .	100	O	O	O	O	O	O	O	O	O	O	O
125 . .	200		O	O	O	O	O	O	O	O	O	O
250 . .	400			O	O	O	O	O	O	O	O	O
500 . .	800				O	O	O	O	O	O	O	O
1000 . .	1600					O	O	O	O	O	O	O

O Within range Out of range

This shot was taken at 1/2 sec. on a tripod with Plus-X film at dusk with passing cars blurred for pictorial effect.

Exposure Metering Range

Though the T4 is fully automatic from 1 sec. to 1/1000 sec., you should be aware that the meter is *not* coupled to high shutter speeds for films slower than ASA 64, nor to slow shutter speeds for films faster than ASA 125. The meter range is given in the diagram on page 56.

If you are inclined to shoot at 1 sec. or 1/2 sec. using an ASA 400 film in your T4 (on a tripod of course), you may reduce the ASA setting on the dial to 100 to make a reading. Then convert the result to the correct manual setting for the ASA 400 film. In the accompanying illustration, taken at 1/2 sec. on a tripod, Kodak Plus-X film was used and the full exposure-metering range was attained by setting the ASA speed at 100 rather than 125, which is a negligible difference in black-and-white film. Blurred

movement was concentrated on, and the camera was allowed to determine exposure in the fading dusk light.

Obviously, when the meter needle on your T4 does not move because the light level is too low, you should switch to flash or floodlights, which is what the camera designer had in mind when he set the metering range.

Depth-Of-Field Preview

The method of checking depth of field through the viewfinder of the T4 differs from that of the N-T3. Here are the simple steps:

1. Note the *f*-stop indicated by the meter needle for the scene you're shooting.
2. Turn the lens-aperture ring from AE to the *f*-stop mentioned in step 1.

The depth-of-field preview lever on the Konica T4 is operational when the lens-aperture ring is set on an *f*-stop, not on AE (above left). If the red signal light goes on when you press the battery-check button on the Konica T4, the battery condition is acceptable (above right). The on/off switch is also a multiple-exposure switch on the Konica T4 (below right).

3. Depress the depth-of-field preview lever. If the depth of field is suitable, you may shoot immediately, and then return the aperture ring to AE or EE for automatic operation.

Warning: Do not take a picture while the depth-of-field preview lever is depressed. You may damage the automatic diaphragm mechanism of the lens.

Meter-Shutter On/Off Control

Like the TC, when the T4 film-advance lever is flush with the body, the meter system is off and the shutter release is locked. To turn the system on, simply pull the film-advance lever out until it click-stops in the "ready" position. It seems easiest to activate the meter and shutter release by flicking the advance lever with your right index finger. In the ready mode, the lever is in the best position for you to advance the film and cock the shutter; and it's not in the way as you compose through the viewfinder. By pressing the on/off switch lightly (usually with your

right thumb), you turn the meter off and save battery drain.

Battery Check

Improved to a point of graphic simplicity, the battery-check method for the T4 is a one-step process. Press the battery-check button next to the film-rewind knob. If the red light goes on, the batteries are okay. When batteries are exhausted, the red signal will not appear.

If you plan a trip, especially to places like Yugoslavia or the bottom of the Grand Canyon, where battery cells for the T4 may be hard to find, take a pair of extra cells along with you. And should your camera be retired for a few months, remove the batteries and store them in the freezer to preserve their power.

Multiple-Exposure Lever

To make two or more exposures on the same negative or slide, you need to cock the shutter several times without advancing the film or the frame counter. The steps to successful multiple exposures are explained in Chapter 2.

The basic techniques for visual results remain the same for the T4, which has its multiple-exposure switch on the back. Simply press the multiple-exposure switch flush with the camera body, (probably with your left hand), and advance the film-wind lever with your right thumb. The shutter is recocked, but nothing else moves.

Shown here are three easy steps for attaching the neckstrap on the Konica T4.

Neckstrap

The proper method of attaching the neck-strap to your T4 is illustrated. This is a new type of fastening and is probably the most convenient method. The neckstrap supplied with Konica T4 is wider and sturdier than any offered.

Please do read all about Konica Autoreflex features and operations in Chapters 2 and 3, because so many details pertain to the new compact T4. However, the feature about to be described is unique to the new model.

THE KONICA AUTO WINDER

The Auto Winder is a miniature camera motor that, when attached to the bottom of the Konica T4, mechanically advances the film and cocks the shutter at the rate of 1.8 frames per second. The Auto Winder, snugly fitted to the T4, is shown in the accompanying illustration. Note the convenient hand-grip strap which is supplied.

The winder is powered by six 1.5-volt AA alkaline batteries or rechargeable nickel cadmium cells loaded in a snap-in tray and held in place by a folding slotted cover. Be sure to place the batteries in their proper plus/minus orientation as indicated on the battery tray, or the winder will not operate. A set of freshly recharged nicad batteries should wind over 100 rolls of film through the camera! You'll know they are becoming exhausted when the winder slows down. The battery tray is attached to the winder by means of a small latch that should be activated manually (there's no spring). An accessory battery pack is available as an instant replacement during long shooting sessions.

The Auto Winder with batteries weighs a mere 15.5 oz., and is attached quickly to the T4 as follows. Fit the guide pin at the right side of the auto winder, next to the coupling spindle, into its receptacle in the base of the T4. Care-

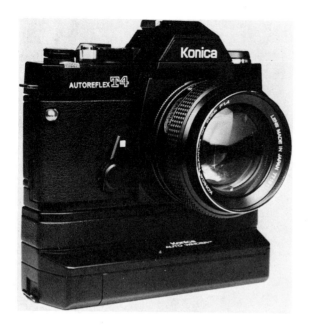

The Auto Winder attaches to the base of the Konica Autoreflex T4 (left). The battery tray (foreground) snaps into the Auto Winder (background). About 40 rolls of film can be shot with one set of AA cells (below).

Operating controls of the Konica Auto Winder for the T4.

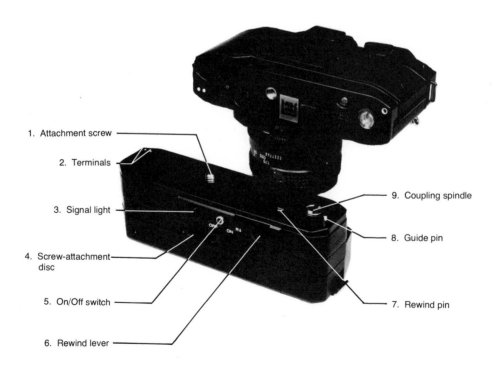

1. Attachment screw

2. Terminals

3. Signal light

4. Screw-attachment disc

5. On/Off switch

6. Rewind lever

9. Coupling spindle

8. Guide pin

7. Rewind pin

fully revolve the screw-attachment disc with your thumb until the screw is firmly seated in the tripod socket of the camera. Two small terminal pins on the left side of the Auto Winder will make contact with their couterparts in the base of the T4.

Now both electrical and mechanical connections are made between the Auto Winder and the camera. To shoot with the winder in place, flip its on/off switch to the "on" position, turn the camera meter/shutter on, and depress the shutter-release button. The Auto Winder offers two modes of operation.

In the first mode, depress the shutter release and lift your finger for one-at-a-time exposures as quickly or as slowly as you choose.

In the second method, hold the shutter release down, and the Auto Winder continuously advances the film and cocks the shutter at the rate of 1.8 frames per second until you lift your finger or come to the end of the roll. At that point, the winder declutches, and a red signal light glows to tell you to rewind the film.

Important: Leave the Auto Winder turned "on" when rewinding the film to avoid camera/winder damage. To rewind, press the lever on the winder marked "R" down in the direction of the arrow. This depresses the camera's rewind button, and you rewind in the normal fashion. Now turn the winder "off."

The camera back may be opened to load and unload film with the Auto Winder attached. You may start the film manually or by using the winder with the back open. There's a tripod socket on the base of the winder.

A snug leatherette case is available to fit the T4 with winder, but if you carry your cameras and lenses in a shoulder bag, store the Auto Winder in the small zippered bag supplied. Incidentally, the winder's flat bottom makes camera stand when a tripod isn't handy (for self-timer or time-exposure photographs.)

SEQUENCE PHOTOGRAPHY

Since an Auto Winder is more compact, lighter, and less costly than a motor drive, owning and using one will appeal to most T4 fans. The Konica Auto Winder can be most valuable in many ways.

You don't have to remove the camera from your eye to advance film, and therefore are less apt to miss action and facial expressions that would have occured "between shots" had you been advancing film manually.

You can conveniently shoot action sequences of racing cars, sports events, children playing, or zoo animals as shown in the accompanying illustrations. Your pictures will tell a sequential story as it unfolds in moments or more slowly. You must still be sharply aware of when you press the shutter button and not depend on chance, except when something happens so fast that you merely hold the button down for dozens of frames.

The Los Angeles Zoo was the setting for some early test pictures with the T4 and Auto Winder; a Hexanon 80–200 mm UC zoom lens was used to photograph flamingos, bears, zebras, and orangutans. The orangutans pictured here are half the frames that were exposed, and all that's needed to tell a story that probably would not have been feasible without the Auto Winder. The Auto Winder gives you new confidence and agility when photographing mobile subjects.

When you take portraits using the Auto Winder, you can watch your model's movements and expressions with easier concentration not easy without a winder. Thus, you are less likely to miss the fleeting moments that help show animation and character. With your camera on a tripod and your subjects seated, or with a hand-held Konica T4 (used to shoot the accompanying series), you can encourage portrait sitters to laugh, talk, and be active, rather than just pose statically. The model shown here seems in doubt, judging by some of her attitudes, but she relaxed, as you can see from the

This kind of picture sequence is made possible by using the Konica Auto Winder.

These photos were taken with the Hexanon 80–200 mm UC zoom lens within a few
seconds span.

fresh look in the final enlargement. This was cropped from frame 21A, and the model also liked frame 10.

There's a substantial feeling about the Konica T4 and Auto Winder combined, which, perhaps surprisingly, allows you to shoot at slow shutter speeds with better sharpness of image. You tend to squeeze the shutter release gently and grip the camera easily. Experiment at 1/30 sec., or even more slowly, and you can see for yourself.

In summary: With the Auto Winder you are better prepared for what's happening in front of the camera. This means potentially more and better negatives and slides under average conditions. You will also choose to shoot in unusual circumstances—where there's action—because you have the winder on hand.

Sequence Techniques

When possible, plan sequence photographs to have a beginning, a middle, and an ending. The latter may be a surprise, a joke, or a logical, physical consequence of the event. You should be aware of how the picture series is evolving, unless it's the hundred-yard dash, when you shoot for nine seconds and that's it! As mentioned before, train yourself not to rely on lucky accidents to supplant skill, but do rely on instinct. You will learn to anticipate movements and expressions, but don't be afraid to shoot, because too much caution is inhibiting.

At first it's natural to be concerned about using film so quickly, but you learn from experience when single shots or full-automatic-sequence is more appropriate. Enjoying the Auto Winder takes some imagination and resourcefulness, as does any piece of new and sophisticated equipment, but this handy accessory opens up vistas for picture-taking that you cannot take advantage of any other way.

The Konica T4 and its Auto Winder are most welcome additions to the line. Make the most of them for a large variety of your photographic adventures.

Lenses for the Konica

As a paraphrase of Gertrude Stein's repetitive statement about a rose, a lens is not a lens is not a lens. This means that to be certain of the best photographic quality in your images, it is wise to choose one of the many Hexanon lenses made especially to couple with the cameras' AE or EE automatic exposure system. These lenses include an AR designation, which indicates their automatic diaphragm operation. Hexanon and Hexar are names given Konica-made lenses. In addition, there are other Hexanon lenses with preset (ARP) and manual (ARM) diaphragm operation and several Hexar lenses.

An automatic lens is open to its full aperture as you view through the finder to compose and focus. As the shutter button is depressed, the lens diaphragm closes to the exact *f*-stop shown by the Konica meter needle, which should result in excellent exposures. Instantly, after the shutter opens and closes, an automatic lens diaphragm opens again to full aperture for brightest viewing and focusing.

A preset lens has two adjacent rings on the barrel, each marked with an *f*-stop scale. The front ring (equipped with click stops) presets the aperture you select manually, and the rear ring operates the diaphragm within the lens, stopping it down to the preset opening at the moment before exposure. After taking a picture, you must open the lens diaphragm manually in order to see the scene brightly, and to focus. A few older Hexanon lenses were preset,

but now there are none marked ARP

A manual lens requires you to manually stop it down to the correct meter-indicated *f*-stop, and open it again after exposure to focus, also by hand. This operation is obviously slower than automatic or preset, but only a few specialized Hexanon lenses are manual, and none of these lenses are used regularly for quick picture-taking.

Lens brands other than Hexanon are made to fit Konica cameras, but it is wise to try any such lenses on your camera carefully before buying, and to purchase them only with the provision that they will focus and operate to your complete satisfaction. These lenses may

The preset lens includes two rings on the lens barrel. The first ring presets the aperture at the selected *f*-stop, and the rear ring operates iris diaphragm within the lens.

seem to mount properly, but only in use will you discover if the camera's meter-coupling cam meets the lens precisely. If the "M" appears in your viewfinder when a non-Hexanon lens is mounted, the lens is functioning manually, whether or not there is an EE or AE marked.

All Konica lenses are fully interchangeable on Konica cameras, from the earliest Konica Autoreflex models to the latest Konica T4. All couple automatically to the Automatic exposure system, showing truly carefully planned design and engineering.

HEXANON QUALITY

At least 30 different Hexanon lenses are made by Konica for use with Konica Autoreflex cameras. Some of these lenses are shown in the accompanying illustration with the N-T3 and TC cameras. Additional focal lengths and types will be introduced when they have been tested and perfected, and existing lenses are sometimes improved by making them smaller, lighter, and more versatile. Because of their design and the fine optical glass developed especially for them, all Hexanon lenses are of superior quality to produce the sharpest images. Each lens has the advantage of what Konica calls "color dynamic coating," which consists of multiple layers of coating to eliminate almost all internal "ghost" images, flare, and reflections. Lens coating is especially important to image quality when shooting into the light, for strong light tends to bounce around within the series of glass elements that make up a lens. Coating helps absorb flared light to produce sharper negatives and slides. If you have ever shot with a noncoated lens, or with one coated before better processes were developed, you will realize how much improved are today's lenses.

Every Konica Autoreflex owner begins thinking about adding more lenses to his or her kit at about the same time the camera is purchased. Though it is not required that you buy a standard or normal-focal-length lens (50 mm) with your camera, it's a good idea, as will be explained shortly. After that, just which optics you will find most useful depends on a number of factors discussed with each following focal-length category. After you have read details about all Hexanon lens groups, the myth of which is the "best" second lens to choose will be examined.

WIDE-ANGLE LENSES

As its name implies, a wide-angle lens covers a field of view that is wider than that of a standard or normal lens—from a given viewpoint. A wide-angle lens can be valuable for these reasons:

1. In a tight place, a small room, or in the midst of a crowd, when you cannot back away to include more area in a picture than you'd get with a 50 mm lens, the wide-angle lens is necessary.
2. When you want better-than-normal depth of field, especially for subjects fairly close to the camera, a wide-angle lens does the job.

3. Choose a wide-angle lens for intentional pictorial distortion that makes foreground objects large and background objects much smaller.
4. To emphasize perspective lines and planes dramatically, especially receding from the camera, use a wide-angle lens.

There are seven Hexanon wide-angle lenses from 15 mm to 35 mm:
15 mm f/2.8 fisheye. Viewing angle 180°, 9 elements in 6 groups; minimum focus 6 in., weight 14 oz.; 3 built-in filters and integral lens shade. This is a full-frame fisheye lens (rather

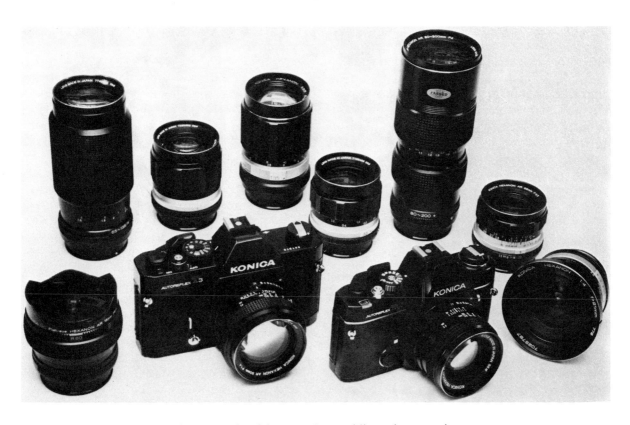

Surrounding the Konica N-T3 and TC are eight of the more than 25 different lenses made for Autoreflex cameras (above). The 15 mm Hexanon fisheye lens produces pictorial distortion not possible with any other focal length lens (below).

than the type that produces a circular image on a 35 mm frame), and it's marvelous for special effects because it stimulates your creativity. Try shooting a multiple-color exposure varying from one to another the yellow, red, and blue filters, which simply revolve into place. The accompanying illustration demonstrates how the 15 mm Hexanon decoratively distorts a light plane to look 50 feet long.

(*Note.* *Elements* refer to the number of glass segments in a lens. *Groups* describe the number of assemblies of elements, according to the lens design, which is determined by a computer for optimum quality.)

21 mm f/4. Viewing angle 90°, 11 elements in 7 groups; minimum focus 8 in., weight 12 oz. Here's a fantastic lens for ultra-wide-angle effects and extreme depth of field as illustrated here, shot from inside a helicopter. The 21 mm lens was a natural in such cramped quarters to assure sharp focus of both my principal subject and the area he was surveying. The 15 mm fisheye would have accomplished the overall focus, but ground details would have been too small. Both the 21 mm and the 15 mm lenses work with the Konica mirror in place; some camera brands require locking the mirror up out of the way to accomodate deep-set wide-angle lenses.

24 mm f/2.8. Viewing angle 84°, 8 elements in 8 groups; minimum focus 10 in., weight 10 oz. This focal length offers very wide-angle characteristics with less possibility of distortion than is inherent in the 21 mm lens. It takes standard 55 mm screw-in filters and accessories, like the 50 mm and 35 mm do, despite its relatively wide maximum aperture.

28 mm f/1.8. Viewing angle 75°, 8 elements in 8 groups; minimum focus 7 in., weight 13¾ oz. Approximately two stops faster than the 28 mm f/3.5 (described next), here is an extremely handy lens for shooting in low light levels indoors or out. A 28 mm lens is an ideal focal length if you want a wider scope that you get

with a 35 mm lens but don't need the 24 or 21 mm lens.

28 mm f/3.5. Viewing angle 75°, 7 elements in 7 groups; minimum focus 12 in., weight 7.4 oz. If you don't need the extra aperture possibilities of the 28 mm f/1.8 lens, choose this lens and save money while you carry about half the weight in glass and metal.

35 mm f/2. Viewing angle 63°, 9 elements in 7 groups; minimum focus 12 in., weight 11.3 oz. One stop faster than the f/2.8 lens (described next), this very practical wide-angle lens is nicely convenient for available-light work, and easier to focus in poor light than the f/2.8 because of the brighter viewfinder image.

35 mm f/2.8. Viewing angle 63°, 6 elements in 5 groups; minimum focus 12 in., weight 8.5 oz. This is the most popular and generally the most useful wide-angle focal length because it is midway between the normal 50 mm and the super-wide 21 mm. Again, when it seems to suit your needs, choose the f/2.8 for economy and because it's less bulky and lighter than the 35 mm f/2.

This was taken with a 21 mm Hexanon f/4 lens from a helicopter.

STANDARD LENSES

There are three standard or normal lenses available in the Hexanon line, plus a fourth that is a variation of the 50 mm f/1.7 that comes with the Autoreflex TC camera.

50 mm f/1.4. Viewing angle 46°, 7 elements in 6 groups; minimum focus 17.4 in., weight 10.2 oz. Many people use this f/1.4 lens as their primary available-light lens. It offers large-aperture benefits in a beautiful optical design with less weight and price than the 57 mm f/1.2.

50 mm f/1.7. Viewing angle 46°, 6 elements in 5 groups; minimum focus 17.4 in., weight 8.5 oz. Possibly the most popular lens in the whole Hexanon repertoire, this 50 mm and its slightly smaller counterpart made for the TC have an inset front element and require no lens hood. The accompanying illustration was taken with this lens at an art museum where this young lady was asked to pose in front of a modern painting because of the simple background. Thus, a 50 mm lens serves for portraits and in many situations where a compromise between focal length and maximum aperture is called for. Some photographers work with a 50 mm lens on one camera and a 35 mm or 28 mm lens on another, one above the other.

57 mm f/1.2. Viewing angle 42°, 7 elements in 6 groups; minimum focus 17.7 in., weight 16.2 oz. This is the champion of Hexanon fast lenses. You carry more weight and pay more money, but you are best prepared for dimly lit scenes. With a slow film such as Kodachrome 25, you can enjoy the advantages of automatic exposure at f/1.2, or close to it, where there's not enough light to shoot at f/1.4 or f/1.7. This is a specialized lens and not for everyone.

A portion of a nonobjective painting was used as background for this portrait made with a 50 mm f/1.7 Hexanon lens set at about f/2.8 and 1/60 sec.

MEDIUM TELEPHOTO LENSES

By arbitrary definition, these four lenses are "medium" telephoto, in the focal-length range between 50 mm and 135 mm. A lens longer than 135 mm is considered to be in the telephoto category.

85 mm f/1.8. Viewing angle 28.5°, 6 elements in 5 groups; minimum focus 3 ft., weight 13.8 oz. This is a fast intermediate-focal-length lens for portraits, landscapes, and such. It has greater dim-light possibilities than the 100 mm but does not "reach out" quite as far.

100 mm f/2.8. Viewing angle 24°, 5 elements in 4 groups; minimum focus 3 ft., weight 10.2 oz. This lens contains less glass, weighs and costs less than the 85 mm, and is ideal for portraits or medium-distant scenes. It's convenient for traveling because of its small size.

135 mm f/2.5. Viewing angle 18°, 4 elements in 4 groups; minimum focus 4 ft., weight 23.5 oz. This lens is 37 percent faster than a conventional f/2.8 lens, making it a good choice for action-oriented photographers who may need fast shutter speeds in poor light. It comes with a built-in, sliding lens hood.

135 mm f/3.2. Viewing angle 18°, 5 elements in 4 groups; minimum focus 3 ft., weight 12.2 oz. with slide-out lens hood. Just about half

the weight of the 135 mm f/2.5 lens, this lens is excellent for portraits, landscapes, sports, or you-name-it. In the accompanying chart of lens specifications note that the length of this 135 mm f/3.2 lens and the length of the 135 mm f/2.5 lens are almost identical, though the weights vary greatly.

The 135 mm Hexanon AR f/2.5 lens.

TELEPHOTO LENSES

Long-focal-length lenses seem to be the "glamour" optics of 35 mm SLR photography, perhaps because they look impressive and "reach out" to record details in the manner of a telescope. Of course, a telephoto lens is most useful for distant scenes that you can't move up to and for candid shots of people taken without your being noticed, as well as for compressing perspective to achieve a "flattened-out" look when an extreme telephoto is used. Keep in mind that carrying a telephoto lens means extra weight and bulk, but you can hang one from your shoulder in its own case.

200 mm f/3.5. Viewing angle 12°, 5 elements in 4 groups; minimum focus 8.2 ft., weight 30 oz. This lens is a relatively fast telephoto offering four times the magnification of a 50 mm lens for sports, wildlife, and so forth. Compare this lens to the 80–200 mm zoom, which more versatile, weighs the same, but costs more.

300 mm f/4.5. Viewing angle 8°, 8 elements in 5 groups; minimum focus 13 ft., weight 2 lb. 2 oz. This lens is only an inch longer than the 200 mm, but offers six times the magnification of a normal 50 mm lens. Some lenses of this focal length are not automatic, but this Hexanon lens has the automatic diaphragm you expect of Konica.

300 mm f/6.3 FL. Viewing 8°, 9 elements in 5 groups; minimum focus 15 ft., weight 19.8 oz.

Edward J. Urbelis made the portrait on the previous page entirely by the light of a match, with a 1-second exposure on Kodachrome Type A film using a 50 mm f/1.4 Hexanon lens. The camera was on a tripod, and the model was held extra steady.

By pressing a 135 mm f/3.5 Hexanon lens against the cage, this tropical bird (right) was photographed without an interfering grid on Eastman 5247 film.

A fisheye lens gives a rounded perspective to this boating scene (below). Both the woman in the foreground and the boats in the background are in sharp focus.

Although backlighting often calls for added exposure, Barbara Jacobs rated Kodachrome 64 normally to retain the contrast and drama at Pt. Lobos, California (left). She used an 80–200 mm UC Hexanon zoom lens set at 200 mm.

With a No. 1 and a No. 2 close-up lens over a normal 50 mm f/1.7 Hexanon lens, the lily was made to fill the entire frame (below). This was taken by Harvey Hill, with floodlights, on Eastman 5247 negative film.

This sunset over a small harbor south of Athens, Greece (left) was photographed with an 80–200 mm UC Hexanon zoom lens on Eastman 5247 negative film.

This colorful popcorn wagon at the Los Angeles Zoo (below) is almost an abstract design, seen with an 80–200 mm UC Hexanon zoom lens on Eastman 5247 negative film.

An English photographer, James Clark, took this fascinating close-up of a Japanese owl moth (above), using a 55 mm macro Hexanon lens and Kodachrome 25 film. The lighting used was two electronic flash units, one on the background.

A 15-second exposure on ASA 125 Eastman 5247 film was used to capture the excitement of night lights in the harbor of Dubrovnik, Yugoslavia (right). The lens used was the 50 mm f/1.4 Hexanon set at f/5.6.

The versatile close-up capability of the 80–200 mm UC Hexanon zoom lens is demonstrated in this pumpkin detail (above). Eastman 5247 negative film was used in daylight.

Medium telephoto lenses, 85–100 mm, are good choices for portraits, such as this one.

Double exposures are so convenient with the Konica N-T3 and T4 because of a multiple-exposure lever that permits cocking the shutter without advancing the film (following page). See text for details.

On an overcast day bright colors seem more vivid. The author's wife in the doorway of an abandoned church in Oregon was taken with a 50 mm f/1.7 Hexanon lens on Eastman 5247 film from RBG (left).

Flamingos at the Los Angeles Zoo (below) make a constantly changing pattern that lends itself well to using a zoom lens, such as the 80–200 mm UC Hexanon zoom. Film is Eastman 5247 from RGB Color in Hollywood, California.

HEXANON LENS CHART

Focal Length	Apertures Max.—Min.	Construction Elements/ Groups	Angle Of View	Min. Focus	Length	Max. Diameter	Weight	Filter	Lens Hood
15 mm UC	f/2.8–f/16	9/6	180°	5.9″	2.5″	2.8″	14.1 oz.	Built-in	Built-in
21 mm	f/4.0–f/16	11/7	90°	7.9″	2.3″	3.2″	12.0 oz.	77 mm	Incl.
24 mm	f/2.8–f/16	8/8	84°	9.8″	2.1″	2.5″	9.9 oz.	55 mm	Incl.
28 mm UC	f/1.8–f/16	8/8	75°	7.1″	2.5″	2.6″	13.8 oz.	55 mm	Incl.
28 mm	f/3.5–f/16	7/7	75°	11.8″	1.7″	2.5″	7.4 oz.	55 mm	Incl.
35 mm	f/2.0–f/16	9/7	63°	11.8″	2.2″	2.6″	11.3 oz.	55 mm	Incl.
35 mm	f/2.8–f/16	6/5	63°	11.8″	2.2″	2.5″	8.5 oz.	55 mm	Incl.
50 mm	f/1.4–f/16	7/6	46°	17.7″	1.8″	2.6″	10.2 oz.	55 mm	705-528
50 mm	f/1.7–f/16	6/5	46°	17.7″	1.8″	2.6″	8.5 oz.	55 mm	705-528
57 mm	f/1.2–f/16	7/6	42°	17.7″	2.0″	2.8″	16.2 oz.	62 mm	705-529
85 mm	f/1.8–f/16	6/5	28.5°	39.4″	2.7″	2.6″	13.8 oz.	55 mm	Incl.
100 mm	f/2.8–f/16	5/4	24°	39.4″	2.4″	2.5″	10.2 oz.	55 mm	Incl.
135 mm	f/2.5–f/16	4/4	18°	47.2″	3.8″	2.7″	23.0 oz.	62 mm	Built-in
135 mm	f/3.2–f/16	5/4	18°	39.4″	3.7″	2.5″	13.8 oz.	55 mm	Built-in
200 mm	f/3.5–f/16	5/4	12°	8.2′	5.8″	2.9″	31.0 oz.	67 mm	Built-in
300 mm	f/4.5–f/16	8/5	8°	13.1′	6.6″	3.2″	34.0 oz.	72 mm	Built-in
300 mm	f/6.3–f/22	9/5	8°	14.8′	5.8″	2.6″	19.8 oz.	55 mm	Built-in
400 mm†	f/4.5–f/45	4/4	6°	26.3′	13.9″	4.1″	5.3 lbs.	55 mm	Built-in
800 mm†	f/8.0–f/45	2/1	3°	65.6′	30.5″	5.3″	12.4 lbs.	55 mm	Built-in
1000 mm†	f/8.0–f/45	7/6	2.5°	82.0′	17.9″	7.9″	18.7 lbs.	55 mm	Built-in
35–100 mm	f/2.8–f/16	15/10	63–24°	10.6″	5.5″	3.4″	38.8 oz.	82 mm	Incl.
45–100 mm UC	f/3.5–f/16	11/10	52–24°	13.8″	3.5″	2.8″	20.6 oz.	55 mm	Built-in
65–135 mm	f/4.0–f/16	13/9	36–18°	59.1″	5.0″	2.6″	21.2 oz.	55 mm	Incl.
80–200 mm UC	f/4.0–f/16	14/10	31–12°	27.6″	6.2″	2.7″	29.5 oz.	62 mm	Built-in
55 mm	f/3.5–f/22	4/3	43°	8.7″	2.4″	2.5″	10.2 oz.	55 mm	Built-in
105 mm	f/4.0–f/22	5/3	23°	28.0″*	1.9″	2.5″	8.1 oz.	55 mm	705-533

*In accessory Konica Auto Helicoid.
†All lenses fully automatic except as indicated.

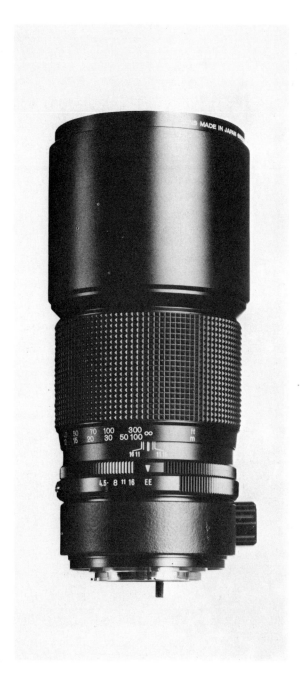

Rare fluorite-crystal elements result in an extremely lightweight lens of this focal length, making it relatively easy to hand-hold. With the f/6.3 maximum aperture, it's mainly an outdoor lens.

400 mm f/4.5 manual. Viewing angle 6°, 4 elements in 4 groups; minimum focus 25 ft., weight 5 lb. 5 oz. These are the heavier, special-purpose telephotos so valuable for nature and sports photography. The diaphragm is set manually, which isn't as much of a drawback as it may sound, because this lens is used with care on a tripod.

800 mm f/8 manual. Viewing angle 3°, 2 elements in 1 group; minimum focus 65 ft., weight 12 lb. 6 oz. The lens includes a folding intergral sight for fast subject location, a filter slot, a pull-out lens hood, and a revolving tripod socket. A Konica brochure says it's "excellent for surveillance operations," which means the well-equipped spy should have one!

1000 mm f/8 manual: Viewing angle 2.5°, 7 elements in 6 groups; minimum focus 80 ft., weight 18 lb. 12 oz. For the price of a half-decent used car, you can have this precise mirror-optic-design lens, only 17.9 inches long with a built-in viewing sight. It offers wonderful possibilities for capturing distance pictures with detail, but unless you are going on safari or have an assignment at the Indianapolis 500, you won't need one to enjoy photography as a hobby.

The 300 mm Hexanon AR f/4.5 lens.

ZOOM LENSES

A decade ago zoom lenses were definitely not as sharp as single-focal-length optics, but today lens design and manufacturing technology are so improved that Hexanon zoom lenses can be compared to any uni-focal types, and their sharpness stands up beautifully. This is not an idle statement, but is based on personal experience. In many situations, it is preferable to shoot with a zoom lens than with a lens of a single focal length, because of the greater flex-

ibility of image size and composition that the zoom lens offers. You should carefully investigate these zoom lenses for the Konica Autoreflex at the same time you shop for *any* single-focal-length type. A zoom cannot substitute for a super wide-angle nor a long telephoto (beyond 200 mm), but in the range between 35 mm and 200 mm, the convenience and pleasure of having an infinite number of picture possibilities at your fingertips should motivate you to check the following Hexanon zooms.

35–100 mm f/2.8 Varifocal. Viewing angle 24–64°, 15 elements in 10 groups; minimum focus 10.6 in. at 35 mm, weight 2 lb. 6 oz. This unusual lens is a *variable-focal-length* lens, rather than a true zoom. The difference is this: As the focal length is changed on this lens, it must be refocused. In contrast, once you focus a zoom lens at a given distance, it stays focused as you zoom to change focal lengths. Thus, the Varifocal is versatile in its wide-angle capability together with its large *f/2.8* maximum aperture. It's good for portraits and architectural interiors.

45–100 mm f/3.5. Viewing angle 24–52°, 11 elements in 10 groups; minimum focus 14.4 in. at 45 mm, weight 20 oz. Just 3.5 inches long, this very handy zoom is marked "UC," which stands for *ultra-close* focusing, a terrific characteristic of this and the 80–200 mm zoom. The lens is very compact because of a special retractable construction; there is an "open/close" ring that is revolved to give the lens normal focusing range. Close-focusing capability provides a 1:4 image, or ¼ life size on the film.

65–135 mm f/4: Viewing angle 18–36°, 13 elements in 9 groups; minimum focus 5 ft., weight 21 oz. Only 5 inches long, this relatively inexpensive zoom has become a favorite for a lot of outdoor shooting, as well as for portraits indoors or out. With a 35 or 55 mm lens on one Konica body and this zoom on the other, one can shoot quite a range of image sizes from a single viewpoint. In addition, this Hexanon makes slides and negatives that are as sharp as those from a uni-focal lens.

80–200 mm f/4 UC. Viewing angle 12–30°, 14 elements in 10 groups; minimum focus 27.6 in. at all focal lengths, weight 29.5 oz.

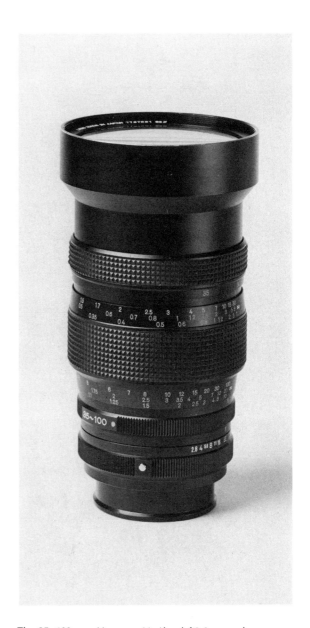

The 35–100 mm Hexanon Varifocal *f/2.8* zoom lens.

You'll find many manufacturers include the 80–200 mm range in their lines because it is so versatile for travel, sports, wildlife, and so many other subjects. This Hexanon focuses and changes focal length so smoothly, that it is a pleasure to use. Just as important, you can shoot 1:2 close-ups *at any focal length;* this is only possible with a limited number of close-focusing zooms.

This is a view through a wet windshield with a 80–200 mm Hexanon zoom lens set at
180 mm (above). Photo below was taken from the same position as the picture above, with
the close focusing capability of a 80–200 Hexanon zoom lens, which provided a sharp
windshield and a blurred background.

The accompanying illustrations demonstrate the flexibility of the 80–200 mm UC zoom. Both were taken through the windshield of a car on a wet day along the Oregon coast. One photograph was shot with the lens set at about 180 mm. It has a partly fuzzy appearance because it was diffused by raindrops shown in the other picture, which was taken by focusing on the windshield itself at the full 200 mm setting. The more you experiment with the possibilities of such a lens, the greater your enjoyment of soft, out-of-focus backgrounds and the instant capability of longshots or close-ups with one portable lens.

CLOSE-UP LENSES

The closest-focusing lenses are in the macro (based on the word *macro* borrowed from the Greek) category. It refers to "large," and in relation to special lenses, it means *to enlarge*. However, a macro lens is also designed for general use, though it offers a smaller maximum aperture than does the normal 50 mm lens.

55 mm f/3.5. Viewing angle 43°, 4 elements in 3 groups; minimum focus from the film plane with 1× extender 8.7 in., weight of lens 10 oz., weight of 1× extender 3.4 oz. With this lens, you can shoot close-ups with relative ease and with better optical quality than you get with accessory close-up lenses. The macro Hexanon, shown in the accompanying illustration, includes the 1× adapter for 1:1 (life-size) images, and of course it operates perfectly on the AE or EE setting. This lens also compensates automatically (by adjusting the diaphragm as you focus) for the extra exposure required at close ranges. In Chapter 9 are several illustrations made with the 55 mm macro Hexanon.

105 mm f/4. Viewing angle 23°, 5 elements in 3 groups; minimum focus depends on how lens is mounted, weight 8.2 oz. This multipurpose macro lens comes in a non-focusing mount and is designed for use with either the Konica Auto Helicoid or an extension bellows. The Auto Helicoid includes an oversized focusing ring to allow this 105 mm macro to focus from infinity to 23.6 inches from a subject. The Auto Helicoid mounts to the camera body like an extender and provides full automatic exposure for the 105 mm macro mounted to it. Use of this specialized close-up lens with the Konica Auto Bellows is described in Chapter 8.

A macro note. These lenses achieve their fine quality because they are formulated to provide superior *resolution* (the ability to sharply record fine detail) plus *flatness of field* (center and edges of a negative or slide are equally sharp and distortion-free). Because of these characteristics, Konica macro lenses outperform other types of close-focusing optics but are just as adept for portraits, landscapes, or other everyday subjects.

The 55 mm Macro Hexanon AR f/3.5 lens with adapter for extreme close-ups.

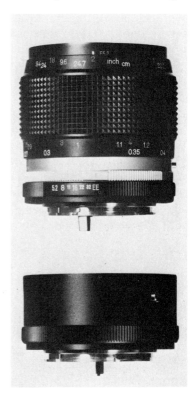

HEXAR AUTOMATIC LENSES

The three following Hexar lenses are made by Konica to the same exacting standards of quality as all system components, but with advanced production methods that allow these lenses to be priced somewhat lower than Hexanon optics of the same focal length. Compare their specifications and cost when shopping for additional lenses in the wide-angle and telephoto categories.

28 mm f/3.5. Viewing angle 75°, 5 elements in 5 groups; minimum focusing distance 11.8 in. from the film plane, weight 6.7 oz. Lightweight and compact (only 1.5 in. long), this 28 mm is a good wide-angle compromise in terms of specifications and cost.

135 mm f/3.5. Viewing angle 18°, 4 elements in 4 groups; minimum focus 5 ft. from film plane, weight 19.5 oz. including built-in retractable lens hood. This lens has almost exactly the dimensions of the Hexanon 135 mm f/3.2, but weighs about 6 oz. more.

200 mm f/4. Viewing angle 12°, 4 elements in 4 groups; minimum focus 8.2 ft. from the film plane, weight 28.3 oz. This lens is lighter in weight than the Hexanon 200 mm f/3.5, and the difference between f/4 and f/3.5 is negligible.

The table on p.73 reviews specifications for all Hexanon lenses and adds details about their dimensions, minimum apertures, and filter-size requirements.

LENS TESTING

Some years ago, before computers were universally used to aid in lens design, and before glass technology and coating techniques were as developed as they are now, many new lenses had to be tested when purchased. Today you can almost assume that a fine lens, such as a Hexanon or Hexar, will be sharp and free of aberrations—the term given optical flaws that cause color shifts, lack of definition, linear distortion, or difficulty in focusing.

However, if you prefer to test a lens before you set out to use it for serious photography, you might buy a lens test chart and go through a tedious process, or you can be expedient and just *take pictures with it.* Mount your camera on a tripod to eliminate movement, no matter what lens you test. Focus at various distances; shoot at a series of lens openings; and keep a record of what you do. Then make, or have made, black-and-white enlargements or color prints for study, or project your color slides on a screen. Examine image sharpness with the naked eye and a magnifying glass; evaluate the authenticity of the color; and decide if the lens performance pleases you. If not, take your pictures and the lens back to the dealer and complain with evidence in hand. Keep in mind that personal standards of judgment may vary, but if you have a legitimate case, a reputable dealer should exchange the lens for another. Don't expect a Hexanon lens to disappoint you; but do test your lenses anyway, because the satisfaction of knowing they are tops can be a pleasant psychological boost.

WHICH FOCAL LENGTHS ARE "BEST"?

To determine which focal-length lens you should buy first, and next, analyze the kinds of pictures you take—or hope to take. If you're doing a lot of portraits, a lens in the 85, 100, or 135 mm category would be most suitable. For sports or wildlife, a telephoto lens, or the 80–200 mm zoom lens could satisfy you easily. And if you work in tight places or need better-than-normal depth of field, check the wide-angle classification for the lens or lenses that *feel* good to you. After all, you should be comfortable with any lens you buy, and if a 35 mm

Exposure through the window of a huge tank, which was once tricky, is now easy with the Autoreflex. This shot was taken with a 52 mm Hexanon lens at 1/125 sec. and f/4.5 on Tri-X film rated at ASA 1000 (right). At a weekend gymkhana, shooting with the Hexanon 80–200 mm zoom lens made this action easy to follow. The photo was made at 200 mm, 1/1000 sec., f/11 on Tri-X film on an overcast day (below).

lens appeals more to your aesthetic sense than a 28 mm lens, don't ignore your intuition.

Sorry, but there is no "best" second or third lens for everyone, because there are so many different needs and priorities. However, you might examine the Hexanon zooms listed previously. One wide-angle lens, one normal lens, and one zoom lens form an affordable, portable "kit" for a lot of picture-taking situations.

Technical note: When depth of field was discussed in Chapter 2, reference was made to depth-of-field tables, a sample of which is shown in the accompanying table, for the normal 50 mm lens. You'll see that for each focusing distance/aperture combination there's a carefully defined set of figures showing depth of field in feet. Tables such as this are available for all popular lens focal lengths in other data books. You need not try to memorize depth-of-field information, nor do you need these tables in order to take good pictures. You should merely be aware of them as a potential reference source.

DEPTH-OF-FIELD (50 mm *f*/1.7 · 50 mm *f*/1.4)

Distance / Aperture	1.5	1.7	2.0	2.5	3.0	3.5	4.0	5.0	7.0	10.0	15.0	30.0	∞
f/1.4	1.49	1.73	1.98	2.47	2.96	3.44	3.92	4.88	6.76	9.50	13.89	25.68	185.00
	1.51	1.76	2.02	2.53	3.04	3.56	4.08	5.12	7.25	10.53	16.25	35.30	∞
f/1.7	1.49	1.73	1.98	2.46	2.95	3.43	3.91	4.85	6.71	9.41	13.69	25.09	152.18
	1.51	1.76	2.02	2.53	3.05	3.57	4.09	5.15	7.31	10.65	16.56	37.10	∞
f/2	1.49	1.73	1.97	2.46	2.94	3.42	3.90	4.84	6.67	9.33	13.52	24.53	133.20
	1.51	1.77	2.02	2.54	3.06	3.58	4.11	5.17	7.35	10.75	16.81	38.42	∞
f/2.8	1.48	1.72	1.97	2.45	2.92	3.39	3.86	4.77	6.56	9.09	13.02	22.88	95.23
	1.52	1.77	2.03	2.55	3.08	3.61	4.15	5.24	7.51	11.09	17.67	43.36	∞
f/4	1.48	1.72	1.95	2.43	2.89	3.35	3.80	4.69	6.38	8.76	12.33	20.79	66.75
	1.52	1.78	2.04	2.57	3.11	3.66	4.21	5.36	7.75	11.64	19.15	53.75	∞
f/5.6	1.47	1.70	1.94	2.40	2.85	3.30	3.73	4.57	6.17	8.35	11.52	18.54	47.77
	1.53	1.79	2.06	2.61	3.16	3.73	4.31	5.51	8.10	12.47	21.56	79.10	∞
f/8	1.46	1.69	1.92	2.36	2.80	3.22	3.63	4.42	5.87	7.80	10.49	15.96	33.53
	1.54	1.81	2.09	2.65	3.24	3.84	4.46	5.77	8.69	13.97	26.61	273.36	∞
f/11	1.44	1.67	1.89	2.32	2.73	3.12	3.51	4.23	5.55	7.22	9.44	13.61	24.47
	1.56	1.84	2.13	2.72	3.34	3.98	4.66	6.13	9.56	16.46	37.71	∞	∞
f/16	1.42	1.63	1.84	2.24	2.62	2.98	3.33	3.96	5.08	6.42	8.10	10.95	16.92
	1.59	1.88	2.19	2.83	3.52	4.25	5.05	6.84	11.51	23.52	126.48	∞	∞

Note: Permissible Aberrated Circle Diameter 3/100 mm (Unit: Feet)

Films and Exposure

While plenty of books about photographic techniques relate to using your Konica, certain facts about films and exposure given here should be useful. Konica automation leaves you free to be more creative, so it's worth learning as much as possible about the art and craft of picture-taking to make the most of your camera's excellence.

FILMS AND FILM SPEEDS

There are three basic types of film for your 35 mm camera, and although it may seem superfluous to compare them, some readers have yet to experiment as thoroughly as they should. The following data may encourage them to try something new.

Film Speeds

Each color and black-and-white film has an ASA rating (film speed) usually printed on the film carton and on the cartridge as well. These are the same numbers found within the shutter-speed dial of the Konica, and when you set an ASA speed on that dial, it guides your built-in CdS meter properly.

There are slow films (ASA 10 to 64), medium-speed films (ASA 80-160), and fast films (ASA 200, 400, and higher). If you generally shoot in good light outdoors, or with flash indoors, a slow or medium-speed film will permit suitable shutter speeds and give you fine grain with excellent contrast. If you need to take pictures where the amount of light is limited, especially indoors, a fast film is preferable. Of course, the functions of these films are interchangeable. You can get great pictures with a slow film in dim light or at night when the camera is tripod-mounted; and with fast film outdoors in bright sun, you can use high shutter speeds, small f-stops, and, if necessary neutral density (ND) filters. There's more about neutral density filters in the next chapter.

Color Slide Films

Photographers who prefer to project their images in well-edited slide shows, choose color slide films, knowing they can also have prints made easily from slides. The old standby by which other positive transparency films are judged is Kodachrome 25 film, also made in a similar emulsion called Kodachrome 64. Kodachrome color is on the warm side and somewhat saturated, which means it's often dramatic in appearance. Kodak also offers E-6 process Ektachrome film, rated ASA 64, 160, and 200. Ektachrome 160 film is for tungsten light

This is not an in-camera multiple exposure, rather, a reflecting window photographed on Plus-X film. Its medium speed and excellent contrast are fine for outdoor work.

(floods and quartz lights), while the other two ASA films match daylight and flash. Ektachrome film colors are less contrasty than those of Kodachrome. Sakura color 100 and 400 are fast, high-quality slide emulsions made by Konica, and standard E-4 processes are used to develop the films.

From Europe, Agfachrome 64 film is warm in color like Kodachrome 25 film. From Japan comes Sakurachrome slide film rated at ASA 100. For a rather offbeat, but satisfying, film, you can try slides made from Eastman 5247 motion-picture negative stock, spooled by several companies and rated at ASA 100 in daylight or tungsten. RGB Color, 816 N. Highland Ave., Hollywood, CA 90038, is a handy source of 5247 film and processing.

Negative Color Films

If you only have color prints made of your pictures, start with a negative film such as Kodacolor II, Sakuracolor (made by the parent company of Konica), or the fast Sakuracolor 400 or Kodacolor 400. The latter two are bringing a new dimension to available-light photography, offering more freedom in shooting indoors, yet they are suitable in bright sun or with flash. If you want to be thorough, experiment with negative and slide films side by side. Have prints and/or slides made from both, and see which you like best.

Black-and-White Films

Slow films have finer grain than fast films, but they also have greater inherent contrast. Therefore, it's easier to hold detail in outdoor shadows with a fast film such as Kodak Tri-X or Ilford's equivalent HP5. Kodak's slow film is Panatomic-X (ASA 32); in the middle is Kodak Plus-X film (ASA 125); and the fast film is Kodak Tri-X (ASA 400). Don't worry about grain. Pay attention to the contrast characteristics of a film in relation to where you shoot most often. Outdoors, Plus-X film is very good, and for available light Tri-X and HP5 are preferable. Actually, if you make only 8″ × 10″ or 11″ × 14″ enlarge-

Reflected light from nearby walls helped make the model comfortable while providing a pleasant effect. Negative sharpness is assured by using a tripod (left). This was taken at Sea World in San Diego with the 80–200 mm Hexanon zoom lens. The softer contrast characteristics of Tri-X film (or Ilford HP5) make it a good choice for some sunlighted situations (right).

ments, any black-and-white film will serve you well, though you should really become familiar with one black-and-white and one color film so you know the feel of them instinctively.

The accompanying illustration shows the desirable tonal qualities of Plus-X film. This portrait was made with a 65–135 mm Hexanon zoom lens on a Konica N-T3 mounted on a tripod. Indirect daylight was reflected from the walls and concrete deck in this outdoor "studio" to give the subject sparkle, and the young lady didn't have to squint.

Film Latitude

In lighting conditions that create either very high or very low contrast, you cannot expect perfect results from any film. However, the films mentioned include a characteristic called *latitude* that may come to your rescue occasionally. Latitude refers to a film's ability to handle lighting extremes along with nominal exposure errors. One stop of overexposure or underexposure with the average black-and-white film will not be difficult to print because film latitude offers some compensation. Negative color films can also be flexible, although overexposure re-

sults in better prints than does underexposure. One stop over or under with a slide film is more noticeable, but these films also have useful latitude to cover small exposure errors or contrast extremes. If you have the option, underexpose one-half stop with a slide film to get better color saturation. (This same recommendation holds if you shoot a negative color film from which you consistently have slides made.)

In any case, you can depend on the Konica Autoreflex exposure system to be an ally of the film you use, and the accompanying illustration is an example. It was taken at Sea World in San Diego, California, with the 80–200 mm Hexanon zoom lens. Exposure was 1/500 sec. at f/16 on Kodak Tri-X film with the lens set at 200 mm. As detailed below, the ASA speed set on the Konica was 200 instead of 400 to get better detail in the bright water.

To gain full awareness of film latitude, make a controlled series of exposures in several lighting-and-contrast situations, and in shade— and keep notes. When you examine the slides or prints you've made, you'll see how flexible (or rigid) the film is that you're using, and you can program your Konica meter accordingly for future precision.

You know from observation that light can be soft and almost shadowless, harsh with dark shadows, or somewhere between. Such variations come from the sun and from artificial sources, or a combination. Floodlights and flash can be controlled in terms of where you place them, whether they are direct or indirect, and how they affect the form you are photographing. In daylight, your controls depend on the time of day or night, the location, and the direction of sunlight or perhaps the glowing light from a hazy sky. All this leads to a brief summary of the types of light you encounter as you make pictures with Konica exposure automation:

Frontlight is just that. It strikes the subject head-on, and in the case of flash-on-camera, frontlight isn't very exciting. Light from the front usually does a poor job of *modeling*, which means to show form clearly.

Toplight is positioned overhead, in front of or to the side of a subject. In the Northern Hemisphere, between late spring and early autumn, the sun provides toplight from mid-morning to mid-afternoon. It is usually not very flattering to faces, and landscapes tend to look formless; but toplight can be functional.

Sidelight often creates form-revealing shadows and pictorial drama. It can also add mood to a picture. The accompanying photograph was taken near a window, and no light was reflected into the shadows purposely, because contrast was desired.

Fine landscape situations are often sidelighted. A football team can show up brilliantly against the field with the sun at one side of the players in late afternoon. Sidelight adds interest to the crowd in the Paris Louvre, taken with a 28 mm Hexanon lens at 1/60 sec. and f/5.6.

Backlight means the main light source comes from behind the subject and is more or less directly into the camera lens. In many cases, backlight is exciting and desirable, providing you expose correctly, which will be discussed momentarily. Minimum exposure will silhouette a figure or object, but when there is enough additional "fill light" to illuminate shad-

Sidelight from a window created a very effective mood in this portrait taken with a 100 mm Hexanon lens.

ows, the effects can be delightful. The charming mother and daughter on p. 85 did not have to squint into the sun, and their faces are evenly lighted—partly by reflection from a concrete deck beside a pool. For this photograph, the Konica metering system gave correct exposure without the manipulation mentioned below.

Diffused light, also called bounced, reflected, or indirect light, was shown in the illustration on p. 82. Sources of diffused light include open shade, overcast skies, and daylight or artificial light reflected from walls, umbrellas, or any bright surface. Portraits in diffused light provide a comfortable situation for the model without shadows that can distort a face. Landscapes may be moody, but a hazy day at the Grand Canyon will not show the form, so directional light is preferred for most outdoor subjects. You can simulate a professional photographic studio in a light-colored room by reflecting light off walls and ceiling for portraits and many still-life subjects.

Side windows in a gallery at the Louvre help show form in people and the building (top). Backlight was used in this portrait of mother and daughter to create a very pleasant pictorial effect (left). When the summer sun is high overhead at midday, the light is not usually good for portraits; but it worked well at a racetrack where a speed of 1/60 sec. at f/16 allowed the passing car to blur. This shot was taken on Ektachrome film rated at ASA 64 (right).

For frontlight, sidelight, toplight, and diffused-light situations, conventional techniques are called for with a Konica Autoreflex. The metering system "reads" the scene and averages highlights and shadows into a specific *f*-stop to match the shutter speed you've set. With this system your negatives or slides should be fine.

However, in unusual lighting conditions, namely backlight and in contrast extremes, the camera meter must be directed by a bit of astute manipulation. First, you should be aware of the Konica's "variable metering system," as the manufacturer calls it. There are two meter cells within the dome of the camera, above the viewfinder. One cell reads a limited "spot" in the center of the finder, while the other averages the light over the complete picture scene. Meter sensitivity is scientifically distributed to meet the requirements of wide-angle, standard, and telephoto lenses as diagrammed in the accompanying illustration. Note how the center area enlarges as focal length increases, on the basis that the most important aspect of the scene is near the center, but the relative area included as "center" is compounded for long-focus lenses.

Experiment by aiming your Konica at a scene using a wide-angle lens, and noting the *f*-stop indicated. Switch to a standard lens, and then to a lens 135 mm or longer, maintaining the same center portion of the picture each time. Compare aperture readings, and you may be surprised to see they differ because the Konica variable metering system compensates for changing views of essentially the same scene.

Backlighting Exposure

This is one of several lighting condition that may "trick" any exposure meter. When backlight *dominates* a scene, the camera meter reacts to its intensity and sets an aperture which, if used, is likely to cause underexposure for figures, faces, or forms in the foreground area. Of course, you may add light to the fore-

28 mm

57 mm

200 mm

This diagram shows the areas of principal meter senzsitivity in the variable metering system.

ground from flash or a reflector, but neither is usually handy. Therefore, consider one of the following easy manipulations:

Temporarily reduce the ASA film-speed setting to one-half the normal rating. This provides an extra stop of exposure, which normally gives you adequate shadow detail without radically overexposing highlights. The accompanying illustration was one of a series shot on Kodak Tri-X film rated at ASA 200 (instead of 400). There's still tone in the water of the pool behind the model; and in color, the blue would have

been somewhat lighter than in actuality, but still quite suitable. Without a reflector, except for the foreground deck, there is plenty of detail in the model's face and clothes. *Remember to reset the film speed* to the proper number when you finish shooting the backlight situation.

If you have an occasional backlighted shot, *maintain the normal ASA setting and move the camera close enough to read only an important subject area (such as a face) that appears in shadow.* As you take the reading, depress the shutter release on your Konica Autoreflex *part way.* This locks the meter needle at the close-up reading. Move back to your intended camera position, holding your finger on the shutter release. When you shoot, exposure will be for the shadowed area you metered, which should have good detail. In this way, the background will probably be overexposed, but its importance is secondary. Should you wish to continue shooting without moving back and forth to and from the subject, simply set the *f*-stop manually, but don't forget to rest on EE or AE afterwards.

Very Dark or Very Light Backgrounds

When there is more-than-average contrast between your main subject and the background, you need to make exposure compensations. Eleanor Bralver made the accompanying still life with a dark background and lighted it with two floodlights over which she placed fiberglass diffusers. Using Kodak Plus-X film, she set the shutter speed at 1/30 sec. (camera on tripod), and the meter needle indicated *f*/8. She shot several frames at these settings and then

This still life by Eleanor Bralver indicated *f*/8 at 1/30 sec. exposure, but black background suggested doubling the ASA, which resulted in an aperture of *f*/11 (on a tripod) for more acceptable negative quality.

doubled the film-speed setting to compensate for the amount of black influencing her meter. She could then shoot at *f*/11 and 1/30 sec., which also gave her better depth of field. When a scene is predominately dark, an exposure meter tends to overexpose, so you must adjust one or both settings accordingly.

Conversely, in a very bright room, for instance one with white walls, you may get underexposure because the meter is attempting to set exposure for high light intensity. When you have darker subjects in which you want shadow detail, give the scene one stop more exposure, either manually or by *halving* the ASA setting. This type of high contrast is parallel to the backlighted situation described previously, and you use the same technique.

CAN YOU TRUST A BUILT-IN METER?

After all the explanation of the excellent Konica Autoreflex built-in metering system, this may sound like an odd question. The answer, of course, is a resounding yes! But you cannot take *any* exposure meter reading for granted. You should consciously analyze each situation you photograph in terms of light direction and subject contrast, as explained. Your mind coupled to your Konica automation should be ready for the most unconventional picture opportunities, from which you should be confident of fine slides and negatives. You *can* trust a built-in meter with an automatic-exposure camera, and you can also trust *yourself*!

As a final note to reinforce the foregoing opinions, there may be times when a photographer will shoot dozens of rolls of film, sometimes color and black-and-white side by side, within a short period such as a day or two. In such cases, three or four Konicas can be kept going constantly, loading spare cameras when there's a few minutes lull. Having to shoot fast, one could be severely handicapped with a match-needle type of SLR, but Konica automation gives reliable, consistent results—even in a rush. Certainly, a few exposures will not be acceptable, but you can usually blame your own judgment in not compensating for backlight or high contrast in fast-changing situations. It is a pleasure to know that Konica Autoreflexes give the means to work quickly—and accurately—to make the images needed for fun or profit.

Konica Accessories

With one lens on one Konica body and one roll of film, you can enjoy taking all sorts of pictures. But additional lenses, several camera bodies, and a few of the items mentioned in this chapter will add versatility to your equipment, no matter what sort of situations you tackle. Already mentioned were a tripod (and Slik is a good brand) and the Konica Auto Winder. Coming up in succeeding chapters is information about flash, and close-up photography and accessories. Here then are other worthwhile items for general and specialized needs.

A favorite portrait lens, the 100 mm Hexanon, was used here with two quartz lights reflected from an umbrella at the left and a third light on the background. It was no problem shooting a 36-exposure roll in five or six minutes, giving the subject little time to be self-conscious.

LENS HOODS AND BODY CAPS

The lens chart shown on p. 73 lists all Hexanon lenses that include built-in lens hoods. For those lenses requiring separate hoods, also called sun shades, Konica makes individual hoods in specific sizes to fit each focal length and type. Some hoods fit more than one lens; but in any case, it is absolutely essential that you use a lens hood for all kinds of photography. Not only is the lens protected from stray fingers and scratches, but extraneous light rays are prevented from causing flare that degrades image quality.

When your Konica is carried or stored without a lens, protect its valuable interior with a flat body cap that covers the area where the lens is mounted. Each Hexanon lens comes with a rear lens cap that should stay on the lens all the time the lens is not on the camera. The rear cap protects the back lens element and the aperture-setting pin.

KONICA ANGLE FINDER 3

Like a small periscope, the Angle Finder 3 allows you to see through the camera viewfinder when the Konica is flat on the floor, high on a tripod, or in some other odd spot. It swivels 360° and you can use it for seeing around corners without being seen yourself.

Angle finder.

CABLE RELEASE AND LENS MOUNT ADAPTERS

The Cable Release 3 is a precision 18-inch device with a lock for time exposures. Use a cable release to fire the shutter at slow shutter speeds when you must prevent even the slightest vibration caused by fingers or hands on a camera. Use the lock to hold the shutter open on the "B" setting.

Konica offers a series of precision lens-mount adapters that allow you to use literally hundreds of different optics in mounts with other brand names, both bayonet and screw-type. It's also possible to use bellows units or extension tubes of other brands on your Konica with the same adapter. The price you pay is stop-down metering, since the "alien" lens doesn't couple to the Konica automatic diaphragm control. However, some of the lenses you may want to adapt are manual or preset.

VIEWFINDER CORRECTION LENSES

These specially ground lenses are screwed into the finder eyepiece to correct vision while focusing and composing for nearsighted or farsighted people who wear glasses. You don't need glasses if you use the +1, +2, or +3 diopter correction lenses (for farsighted), or the −1, −2, and −3 lenses for the nearsighted. Correction lenses for the TC and T4 models are made in a rectangular shape to slide into the slots on either side of the eyepiece. There is also

an eyepiece converter for the TC and T4, which slides into the eyepiece slots, but has a circular thread to accept an angle finder or magnifier. In addition, you can buy a 2× magnifier for more precise focus, plus an eyecup, which shields the viewfinder (and meter) from extraneous light for eyeglass wearers. The magnifier moves out of viewing position when not needed.

CAMERA CASES

Standard-size and elongated hard and semi-hard snug-fitting cases are available for each Konica model. They do protect your camera while it's carried or stored; but they can get in the way, and the front portion either dangles or has to be carried separately.

You might prefer using a shoulder bag fitted for several camera bodies and lenses, plus accessories, film, and other gadgets such as lens cleaner or cable release. Such bags are made by many companies, but there's one compartmental case made especially by Konica for its own equipment. This handsome unit is 9.9 inches high, 13 inches wide, and 9.4 inches deep. It can be carried to open away from the photographer, and it holds any Konica body with a wide-angle or standard lens, one body without lens, plus four more lenses from 15 mm to 300 mm. These attach to metal lens mounts within the case. You can also carry an electronic flash unit, filters, etc. and there's an outside pocket for film. Called the "Professional Compartment Case," it's sturdy and looks elegant.

A Konica professional compartment case is fitted to hold two camera bodies and at least four lenses.

KONICA FILTERS

Made with the same precision as Hexanon lenses, Konica filters do many things pictorially, or they correct the color of light to match film. Filters screw into the front of a lens; since exposure is determined by through-the-lens metering, there's no need to make any compensation or setting for a *filter factor*. The accompanying chart explains Konica filters and effects.

KONICA FILTERS AND THEIR USES

Color of Filter	Name	Effect
Colorless*	UV(L39)	Absorbs ultraviolet light at high altitudes or in snow or at the beach, and prevents excess blue. Has some effect in penetrating atmospheric haze.
Light Yellow	Y1(Y44)	All three of these absorb blue, violet, and ultraviolet. For use with B & W films only, especially to darken skies, make clouds stand out.
Yellow	Y2(Y48)	
Dark Yellow	Y3(Y52)	
Orange	O1(O56)	Absorbs more blue than a yellow filter, and darkens skies even more dramatically.
Red	R1(R60)	Absorbs blue and green; blue skies rendered almost black. Used for strong contrast effects in B & W; also used with infrared film.
Yellowish Green	PO 0	Renders greens better than yellow filter with B & W films. Helps prevent washed-out flesh tones when face is against the sky.
Light Gray	ND 2	ND refers to neutral density filters which do not affect colors with B & W or color films. Used to reduce light intensity and prevent overexposure with fast films. Permits larger lens openings for selective focus and depth-of-field control.
Gray	ND 4	
Dark Gray	ND 8	
Light Pink*	Skylight	For color or B & W films. Absorbs UV light and prevents excess blue cast in shadows or distant scenes. Particularly useful with Kodachrome.
Light Amber*	A 2	Warms the light in the shadows of snow or beach scenes. Prevents excess blue cast on cloudy days, or in open shade.
Light Blue*	B 2	Cools the color of reddish light of early morning or later afternoon sun. Use only for correction, since reddish cast may be useful effect.
Blue*	B 8	For use with clear (white) flashbulbs and daylight-type color films. Prevents excessive warm tones.
Dark Blue*	B 12	For use with 3200 K floodlight bulbs and daylight-type films to correct color.

*Filters most commonly used with color films.
Note: Filters from other manufacturers may be the same or similar colors, but have different names or numeric designations.

Flash with the Konica

Many photographic opportunities become available when there is too little ambient light (also called *existing* light). Thus, it is a natural to use flash to get negatives and slides that might not be possible otherwise, and current Konica Autoreflex models make picture-taking with flash a delight. Techniques for using the Konica and a flash unit are easily learned, perhaps too easily, because there is sometimes a tendency to be expedient when a little more effort can make the difference between an ordinary and an outstanding image.

Bounced electronic flash gives a soft, pleasant light that spreads beside and behind the subject; direct flash directed towards the camera would have been harsh.

ELECTRONIC FLASH PHOTOGRAPHY

In this day and age, flash means *electronic* flash to most photographic enthusiasts. One reason is the excellent variety of electronic flash units available, some of them the size of a package of cigarettes, and many of them with auto-exposure capability. (Flash exposure will be covered momentarily.) Using an electronic flash unit means there is no need to carry a lot of flashcubes that are only good for four shots each and do not "freeze" action very well. It is far wiser to buy an electronic flash unit, the cost of which will be amortized in a year or so. You avoid having to change cubes, the flash is extremely fast to stop action, and there's no guesswork with an automatic unit.

Basics of Choosing a Small Electronic Flash Unit

There are many popular and reliable brands including three models from Konica. Their relative light output is rated by a guide number (explained below), usually for ASA 25 film, which is the old standby Kodachrome film. You have other options that make a unit more versatile and usually more costly, including a swivel head, remote sensor, number of *f*-stops for operation, and extent of power supplies. Briefly, a unit with a guide number of 56 for Kodachrome 25, for instance, means you can shoot at *f*/5.6 at 10 feet or *f*/8 at 7 feet, compared to a more powerful unit with a guide number of 90. Divide

the number of feet from camera to subject to obtain the *f*-stop for a specific film and electronic flash unit.

Consider the variety of batteries a unit can use. Most can be powered by alkaline (the best dry cells) or standard carbon-type AA cells from which you can get 100 to 200 flashes per set, depending on the unit. Some electronic flash brands and models also operate on nickel cadmium (nicad) batteries that are rechargeable. Nicads cost more, but if you shoot several times a month and keep them properly charged, you have no further replacement expense. Finally, a unit that works on AC power or on high-voltage batteries may be worth having, depending on your needs. Certainly, being able to plug the unit into a wall socket and shoot without worry about depleting batteries is a real asset when AC is convenient.

Larger, two-piece units, or those with handle grips, are very versatile but cost a lot more than a unit such as the Konica X-28. You only need an elaborate electronic flash unit when your picture-taking needs are unusual; for example, when covering fairly large areas in color, or repetitive pictures in a limited time.

Shown here are three Konica flash units. The Konica X-28 Automatic (left) has auto operation from 24 inch to 16.4 feet. A choise of lens openings allows depth-of-field control. It has a swivel mount for optimum coverage, and gives approximately 200 flashes on four standard AA alkaline batteries. The X-20 (center) is exceptionally compact for cordless or cord-type operation. The guide number 64 (feet), 20 (meters) with ASA 80/125 film permits shooting distances to 40 feet with an *f*/1.7 lens. It gives up to 400 flashes with four standard AA alkaline batteries. The X-14 (right) is a small cordless electronic flash, with a guide number 45 (feet), 14 (meters) with ASA 80/125 film. It permits shooting distances to 28 feet with an *f*/1.7 lens, and gives some 200 flashes with two standard AA alkaline batteries.

The Ascor Auto 1600 system (left) with bare-bulb attachment, remote battery charger, and remote sensor is typical of larger, more sophisticated electronic flash units. (Right) This was shot with a small electronic flash unit on the Autoreflex, a 35 mm Hexanon lens, and Tri-X film.

Recycling is the term applied to the interval during which an electronic flash unit builds up power again after being flashed. Recycling time depends on the power source and type, the size of the unit, condition of batteries, and often, the distance from the flash to the subject. An average small unit operating on alkaline batteries may recycle in 3 to 9 seconds. An auto-exposure with a *thyristor circuit* (which returns unused power to the unit efficiently) may recycle in less than a second when a subject is only a few feet away. Inquire about recycling time for a unit with different types of batteries and with AC as well.

Price is not always an indication of quality or light output; however, more expensive electronic flash units are usually more powerful. Some units have a dial by which you can regulate the amount of light flashed, and some include a number of useful accessories such as fast chargers and pistol grips. Shop with care, because the electronic flash unit you buy today should last a decade.

Auto-exposure Electronic Flash

In my opinion, the best buy today in electronic flash is a unit that includes a tiny sensor to measure the amount of light necessary for proper exposure of a subject, according to the film speed (set on a dial) and the distance from

flash to subject. Such an auto-exposure unit quenches the light automatically under many conditions, which means you save effort and are guaranteed almost consistently good exposures. It is important to compensate for light or dark reflecting surfaces in a room in order to program an auto-exposure unit, but it is not a difficult task.

The alternative to auto-exposure is to determine a proper *f*-stop for a specific situation using a guide number, mentioned earlier. The camera lens is set manually on a specific *f*-stop, according to the calculator dial found on most electronic flash units, or by dividing the number of feet into the guide number to obtain the aperture setting. Guide numbers are easy enough to use, but as you change the distance from flash to subject, you must alter the *f*-stop, all of which is very time-consuming. Therefore, choose an auto-exposure unit, read the instruction book for it thoroughly, shoot one experimental roll to get to know your equipment, maintain proper battery power, and don't get involved with guide numbers, except to compare units.

Using Electronic Flash with a Konica Camera

It should be apparent that your camera's EE or AE system is not designed to set exposure

95

for flash, the duration of which may be 1/1000 sec. or even 1/5000 sec. Therefore, *all* electronic flash techniques require that *you* set the f-stop of the lens to match the unit and the situation you're shooting. For instance, if you photograph a group 12 feet away, you can usually shoot at *f/4* without concern for depth of field. However, if your subject is 5 feet away, you can set the lens at *f/8* or *f/11* for greater depth of field, and because the light intensity is greater at closer range. Follow these easy steps to shoot with flash:

Connect flash unit to hot-shoe terminal. The N-T3, the TC, and the T4 Konicas all include a hot-shoe connection within the accessory shoe atop the prism dome. If you have an electronic flash unit or a cube adapter with a direct hot-shoe terminal, simply slide it into the camera shoe, turn the unit on, and set the camera.

Attach unit's PC cord to "X" terminal. Should your flash unit not have a hot-shoe connection, attach its PC cord to the "X" terminal of the camera for electronic flash. Only an "X" terminal is included in the TC and T4 models, while the N-T3 has an "M" terminal as well.

Set shutter speed. When the shutter is activated for an exposure, a synchronizing mechanism within the camera fires the flash at precisely the instant when the shutter is *fully open.* The Copal Square Konica shutter allows you to shoot at 1/125 sec. or slower with electronic flash, an advantage noted later for flash-fill outdoors. The accompanying chart gives the permissible shutter speeds for all types of flash for three Konica models. If you accidently set the speed at 1/250 sec., you will get a half-exposed slide or negative because the shutter was not fully open, during the flash interval.

Shutter speed for bright locations. When you shoot in a relatively bright location, especially where windows may appear in your pictures, set your shutter speed at 1/125 sec. with electronic flash for a more balanced exposure. If you want some of the room light to register and it's bright enough to do so, shoot at 1/60 or 1/30 sec. with electronic flash. Keep in mind you may get "ghost images" when the ambient light is as strong or stronger than the flash.

Focus, set f-stop, shoot. Focus, set the lens opening according to the unit, the film speed, and requirements of distance, and shoot. Expect an auto-exposure unit to give you well-exposed images, but learn what controls you must exercise in unusual circumstances.

Shooting close to subjects. If you must shoot very close to a subject and cannot regulate a unit's light output mechanically, try a neutral density filter over your lens to reduce the amount of light passing through by 2× or 4×. Or use bounce light.

FLASH SYNCHRONIZATION FOR KONICA AUTOREFLEX-T3

Contact	Bulb / Shutter speed	B	1	2	4	8	15	30	60	125	250	500	1000
M	Class M	O	O	O	O	O	O	O	O	O	O	O	O
	Class FP	O	O	O	O	O	O	O	O	O	O	O	O
	Class MF (flashcube)	O	O	O	O	O	O	O	O	O	O	O	O
X	Class MF (flashcube)	O	O	O	O	O	O	O	×	×	×	×	×
	Electronic Flash	O	O	O	O	O	O	O	O	O	×	×	×

O Synchronized × Not synchronized

FLASH SYNCHRONIZATION FOR KONICA TC

Con-tact	Bulb	Shutter speed	B	8	15	30	60	125	250	500	1000
X	Electronic Flash		○	○	○	○	○	○			
	Class M		○	○	○	○					
	Class MF (flashcube)		○	○	○	○					

○ Synchronized Not synchronized

Off-camera flash. Experiment with removing your electronic flash unit from the camera and holding it at arm's length so it doesn't always flash directly at a subject. If you have two electronic flash units or can team up with a friend who also has one, try multiple flash effects with one unit at the camera and another off to one side activated by a small, remote flash sensor-eye. Two lights often give exciting effects and better form to most subjects.

Bounce Lighting

Flash-on-camera is expedient and often necessary, but the results are not visually pleasing. As a variation, try aiming your flash unit at the ceiling (or a wall). The ceiling (or wall) becomes a reflector from which the light bounces in a relatively soft and even manner, helping to avoid harsh shadows. This can become a favorite technique once you've tried it, because it creates a more natural look without a black shadow behind a person; subjects are more comfortable, too, because they don't look directly into the blinding flash.

In order to point your flash unit upward, it must have a swiveling head, or you may mount it in an extender (Rowi makes a good one) that rotates in various directions. The extender fits into the accessory shoe of your Konica, which disconnects the hot shoe, so use a PC cord.

If yours is a manual exposure unit, a good rule of thumb is to calculate the *f*-stop for bounce light as if it were direct flash at ten feet. *Then open the lens two stops.* You need a larger aperture because the ceiling or reflecting surface returns only part of the light onto the subject. If a ceiling is bright white and lower than usual, open the lens only one-and-a-half stops. When you are eight feet or more from a group,

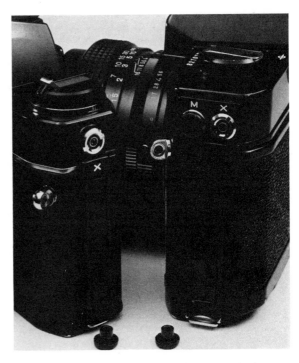

The single "X" terminal on TX and T4 cameras is shown at the left, with the dual-terminal N-T3 at the right.

FLASH SYNCHRONIZATION FOR KONICA T4

Con-tact	Shutter speed Bulb	B	1	2	4	8	15	30	60	125	250	500	1000
	Electronic Flash	○	○	○	○	○	○	○	○	○			
X	Class M	○	○	○	○	○	○	○					
	Class MF (flashcube)	○	○	○	○	○	○	○					

○ Synchronized Not synchronized

for instance, tilt the flash slightly forward to aim it at the ceiling area between you and the group. Experiment with bounce-flash effects and exposure so you'll have confidence in a variety of different situations.

Using an auto-exposure electronic flash unit with a removable sensor or capability to direct the sensor at the subject when the flash is bounced, you can rely on the unit for exposure just as if the flash were direct. In my opinion, it's worth the extra money to buy an electronic flash unit that provides automatic bounce exposures, because people look so much better in reflected light.

Bounced electronic flash was used about four feet away from the smiling man shown here. Direct flash would have been harsh, and perhaps too close for correct exposure with Kodak Tri-X film. However, the ceiling distributed the light evenly over all three men. The exposure was 1/125 sec. at f/8 with a Hexanon 50 mm lens. Sometimes Tri-X can be rated at

This photo was taken with a 50 mm Hexanon lens and bounced electronic flash. Exposure was 1/125 sec. at f/8 on Tri-X film rated at ASA 1000.

This was shot with Panatomic-X film at 1/125 sec. and *f*/11. Notice that the shadows do not reveal much detail (left). Photo on right was shot with the same exposure as the photo on the left, but the shadows were filled by using a small electronic flash unit.

ASA 1000 and developed in Acufine, which allows the use of small electronic flash units more effectively. Slow films do inhibit the use of bounce flash, because a guide number of 56, for instance, becomes the equivalent of 28 when you open two stops. If you cannot get the results you want with your electronic flash unit and a slow film, switch to a faster ASA rating.

Flash-fill.

A special joy of all Konica Autoreflex models is their ability to synchronize for electronic flash at 1/125 sec. This means you can shoot outdoors with a medium-speed or slow-speed film and use flash to illuminate or fill shadows in bright sunlight. Whether the subject faces the sun or has its back to it, the flash gives shadows more detail and better tonal or color balance. Here are the steps for flash-fill:

1. Set the ASA speed dial; set the shutter speed at 1/125 sec. Use the EE or AE setting.

2. If the meter needle shows overexposure at 1/125 sec., switch to a slower film, or use a neutral density filter to cut film speed one-half or one-quarter. Neutral density filters can be used with color or black-and-white films equally well.

3. Focus and note the distance to the subject. With an electronic flash unit that has a guide number between 40 and 80, you should be able to "tame" the flash—that is, prevent it from overpowering the daylight when you are six feet or more from the subject. If the exposure for flash alone is around *f*/11, and the indicated daylight aperture is *f*/16, the flash-fill balance should be fine. If necessary, diminish the flash to half-power or less (on units that have such a control), or shield part of the flash with your fingers or a piece of facial tissue. Make some experimental shots at a series of dis-

This is a triple self-portrait made by multiple electronic flash exposure.

tances on a bright day, and keep notes. Make yourself a chart of film speeds, flash distances, and diffusion methods if necessary. Test flash-fill up to 12 or 15 feet to determine where it is not effective.

The illustration on page 99 demonstrate flash-fill in use. The Konica was loaded with Kodak Panatomic-X film (ASA 32), and the exposure in the picture on the left was 1/125 sec. at about f/11. Shadows are lighter than normal because there is some reflection from the water. The picture on the right was shot at the same exposure, and the shadows were filled by a small electronic flash unit about eight feet using a 50 mm Hexanon lens. This lighting is more pleasant, and when shadow detail is important, flash-fill is handy.

Note: Since the author feels strongly about electronic flash, the use of flashcubes is soft-

pedaled here. If you choose to shoot with flashcubes, buy an adapter, set your shutter speed at 1/30 sec., expect a certain amount of blur from fast-moving subjects, and have fun. If you figure out an easy way to bounce a flashcube, good for you.

Bizarre note: With an N-T3 on a tripod at night, the shutter-speed dial on "B," and the 50 mm Hexanon lens at f/8 (with Kodak Plus-X film), the triple-self-portrait shown here was made. Of course, the multiple-exposure lever was used as well, and positions were taken in three different places. The electronic flash unit was in hand in the larger center figure; the light was bounced against a white outside wall for this and the small head in the bottom left corner. For the spooky center figure, the light was held just above the knee level, but failure to adjust the power caused the negative to be overexposed—which adds to the bizarre note.

Close-Up Photography

A single-lens reflex camera makes close-up photography so easy, with exact composition possible through the viewfinder, that it's no wonder Konica Autoreflex owners often focus on subjects only 18 inches from the normal 50 mm lens and closer with wide-angle lenses. Close-up photography, however, usually means making pictures at magnifications greater than normal lenses permit, using accessories such as rings, bellows, attachment lenses, or a macro lens. Konica offers a complete system of equipment to photograph a bee larger than life, or a postage stamp, or the center of a flower. In the system, there are also adapters for microscopes, special copy stands, precision bellows, and other goodies briefly described in this chapter. Many of these accessories operate with the automatic EE mode of the Konica, making exposure a minor concern.

A bee was photographed from a distance of 8 inches with a 55 mm macro Hexanon lens. The negative was cropped in printing.

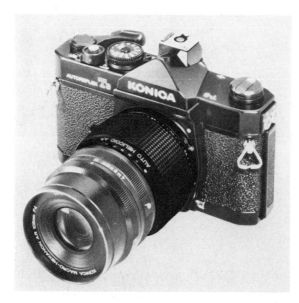

The Konica Auto Helicoid is shown between a Konica N-T3 and a 105 mm Hexanon *f*/4 macro lens. This device is described later in the book as a variable-focusing extender with many close-up functions.

sible with the film and lighting available. Use a cable release to avoid minimum camera vibration, or put the self-timer to work for hands-off operation.

Copying

If you copy something flat such as a photograph or a map, either fasten it to a wall and line up the camera squarely in front of it or use a copy stand, (Konica makes one). A stand has precise up-and-down movements, and the base is painted a neutral 18 percent gray as an exposure aid when the subject you are copying is too tiny to meter alone.

There are several ways to shoot an enlarged, close-up image, and for general photography the best of these is through the 55 mm macro Hexanon *f*/3.5 lens described in Chapter 5. With excellent optical advantages, and no fuss, you can obtain a 1:1 (life-size) record, and use the 55 mm macro as a normal lens as well.

Other methods include adding close-up attachment lenses, extension rings, or the Konica Auto Helicoid, shown mounted between an N-T3 and a 105 mm macro Hexanon lens in the accompanying illustration. Other equipment such as bellows allow even closer focusing and will be covered later.

No matter what means you use to make close-up pictures, there are some basic principles to keep in mind.

Konica Copy Stand II.

Focusing and Depth of Field

The closer you focus to any subject, the less depth of field you get with *any* lens or special macro equipment. Therefore, when shooting close-ups, it is good practice to use a tripod (enlarged detail shows the slightest camera movement) and shoot at the smallest *f*-stop pos-

Lighting

Proper lighting is an aid to good close-up photography. Briefly, a main light from a fairly shallow angle helps show surface textures and form. Outdoors, choose a time of day when the sun is relatively low; and indoors, place your floodlights or flash to accentuate the main lines or features of the subject. A low backlight was used to illuminate the slice of orange shown here, and another floodlight pointed at a re-flecting umbrella served to fill the shadows. This kind of surface with almost no texture is tricky to light. You must place your lights close enough but keep them out of the way, so the heat is not objectionable to the subject. Dentists, who photograph inside the mouth, often use a circular electronic flash unit around the camera lens for even lighting. Experiment with such equipment for your own needs.

This close-up view of an orange slice was shot with No. 1 and No. 2 attachment lenses on a 52 mm Hexanon lens, 9 inches from the orange.

Exposure

The farther you move a lens from the film plane, the greater the distance the light must travel; light intensity is diminished, and thus exposure must be increased. With attachment lenses, extension rings, and either a macro Hex- anon lens or the Konica Auto Helicoid on your camera, the through-the-lens metering system compensates for exposure, and no manual adjustments are required. With a bellows on the camera, exposure is a little more complex, as is explained later.

ATTACHMENT LENSES
AND EXTENSION RINGS

The least expensive means of image magnification is a close-up lens that screws directly into the front of a 50 mm Hexanon lens, or any lens of the same 55 mm diameter. Konica offers two close-up lenses. No. 1 has a focusing range from 12 to 25 inches; No. 2 focuses from 10 to 14 inches; in combination, No. 1 plus No. 2 allow you to shoot between 9 and 12 inches from a subject. The photo below was made using these lenses in tandem—No. 2 should be fitted to the camera first. You can also buy other close-up lenses (or extension rings). Some lenses come in sets of three and permit photographing as close as 6 inches from the subject.

Extension rings allow you to mount a lens at various distances from the camera body, giving you greater magnification than close-up lenses, plus the advantage of no add-on optical influ- ence. Konica's Extension Ring Set 3 consists of three numbered rings of different widths, plus a lens reversal ring, a camera base ring, and a lens base ring. You select the ring or rings according to the enlargement you wish. Exposure is by the stopped-down method described in Chapter 2. You can convert to automatic diaphragm control with the accessory Auto-Ring 2 and Double Cable Release mentioned in this chapter.

Extension rings are mounted to the camera base ring, which bayonets to the camera body. All three rings give you a 1:1 (life size) image. For close-ups greater that 1:1, reverse the lens using the reverse ring in this set to attach it to the Konica body or to an extension ring in front- forward configuration. This may sound strange, but normal lens optics are better for macropho- tography when mounted "backward."

Konica Extension Ring Set III: (left to right) camera ring, 5 mm; extension ring, 8 mm; extension ring, 16 mm; extension ring, 24 mm; lens ring, 5 mm; and reverse ring, 30 mm.

KONICA AUTO HELICOID

This is a special lens mount with continuously variable focusing that becomes a versatile extender into which you mount a Hexanon lens, such as the 105 mm *f*/4 macro or others. You can focus from infinity to 23.6 inches from the lens front using the 105 mm; and with a longer-focal-length lens such as the 135 mm Hexanon, you get a 1:1 magnification. One advantage of using lenses in the 85 mm to 135 mm range with the Auto Helicoid is being able to work at greater lens-to-subject distances, giving you extra space for lights when you photograph small objects. The Auto Helicoid is shown in the illustration on p.102 , and specifications for this accessory are shown along with an assortment of lenses in both normal and reversed positions.

The magnification ratios listed relate the actual size of a subject to the size it is recorded on film. Direct-reading ratios are inscribed on the Auto-Helicoid barrel, so you can shoot without references to a chart. For even greater image enlargement, you focus with the Auto Helicoid *and* the focusing ring of the lens itself.

MAGNIFICATION RATIO/FIELD SIZE CHART FOR KONICA AUTO HELICOID

| Konica Lens | | WITH LENS ONLY | | WITH KONICA AUTO HELICOID | | | | | |
| | | At Minimum Focus | | Mimi-mum | (Lens at Infinity) | Maxi-mum | (Lens at Infinity) | Maxi-mum | With Lens at Minimum Focus |
		Mag.	Field Size	Mag.	Field Size	Mag.	Field Size	Mag.	Field Size
35 mm *f*/2.0	N	0.175×	137 × 205 mm	1.34×	17.9 × 26.9 mm	1.9×	12.6 × 18.9 mm	2.1×	11.4 × 17.1 mm
35 mm *f*/2.8	R			2.75×	8.7 × 13.1 mm	3.3×	7.3 × 10.9 mm		
50 mm *f*/1.4	N	0.16×	150 × 225 mm	0.94×	25.5 × 38.3 mm	1.3×	18.5 × 27.7 mm	1.46×	16.4 × 24.6 mm
50 mm *f*/1.7	R			1.55×	15.5 × 23.2 mm	1.97×	12.2 × 18.3 mm		
55 mm *f*/3.5	N	0.5×	48 × 72 mm	0.85×	28.3 × 42.4 mm	1.25×	19.2 × 28.8 mm	1.75×	13.7 × 20.6 mm
	R			1.45×	16.6 × 24.8 mm	1.8×	13.3 × 20.0 mm		
57 mm *f*/1.2	N	0.175×	137 × 205 mm	0.82×	29.3 × 43.9 mm	1.18×	20.3 × 30.5 mm	1.36×	17.6 × 26.5 mm
	R			1.5×	16.0 × 24.0 mm	1.85×	13.0 × 19.5 mm		
85 mm *f*/1.8	N	0.11×	218 × 327 mm	0.55×	43.6 × 65.5 mm	0.8×	30.0 × 45.0 mm	0.91×	26.4 × 39.6 mm
100 mm *f*/2.8	N	0.13×	185 × 277 mm	0.47×	51.1 × 76.6 mm	0.69×	34.8 × 52.2 mm	0.82×	29.3 × 43.9 mm
105 mm *f*/4.0	N			0.0×	(Infinity)	0.2×	120 × 180 mm		
135 mm *f*/2.5	N	0.15×	160 × 240 mm	0.35×	68.6 × 103 mm	0.51×	47.0 × 70.6 mm	0.66×	36.4 × 54.6 mm
135 mm *f*/3.2	N	0.195×	123 × 185 mm	0.35×	68.6 × 103 mm	0.15×	47.0 × 70.6 mm	0.71×	33.8 × 50.7 mm

Direction:
N = Normal
R = Reverse

Note: All values are approximate.

KONICA AUTO RING AND DOUBLE CABLE RELEASE

This accessory makes possible semi-automatic diaphragm control with extension rings or with a bellows, as described next. One of the twin cables screws into the auto ring to operate the diaphragm, and the other cable attaches to the shutter-release button shown on an earlier Konica model in the accompanying illustration. There's a yellow lever on the ring by which you flip open the lens aperture for viewing and focusing; the Auto Ring closes the aperture just before an exposure is made. The Double Cable Release has a locking collar for

Auto Ring and Double Cable Release. One of the twin cables screws into the Auto Ring, and the other cable attaches to the shutter-release button.

time exposures. This piece of equipment is a must for use with a Konica Auto Bellows.

KONICA AUTO AND STANDARD BELLOWS 3

For more precise close-up photography, when you need full latitude in lens-to-subject distance, a Konica bellows is a natural. At the top of the line is the Auto Bellows on p. 107 with a 105 mm macro Hexanon lens attached. The Auto Bellows is a sophisticated means of attaining continuously variable magnification with the camera on a tripod, a copy stand, or in conjunction with a Slide Copier.

A bellows mounts to a Konica body via the lens bayonet, and each bellows comes with an instructional brochure giving you complete details for operation. If you mount the Auto Bellows on a tripod and want to rotate it to a right angle, there's a focusing rail attachment. Using a reverse lens-mount adapter ring, you can get

so close to a subject that it often becomes unrecognizable.

The Standard Bellows 3 is somewhat simpler than the Auto Bellows and costs less as well. It has no focusing rail to move the entire bellows assembly; you move the front portion only along the rail. The rear standard has an ungeared track with locking knob; there's no lens-diaphragm coupling to permit depth-of-field previewing and semi-automatic exposures; and the Standard Bellows 3 cannot be used on the Konica macro stand. However, you can convert to automatic diaphragm control with the Konica Auto Ring and Double Cable Release, and this Standard Bellows 3 can be used with the Slide Copier.

ADDITIONAL CLOSE-UP EQUIPMENT

Slide Copier

Unusual creative effects are possible when you copy your own slides, life-size or larger, using colored light, perhaps, or making multiple exposures. You may also shoot black-and-white negatives of color slides to extend the

usefulness of certain pictures. One method is to place a slide in front of a piece of opal glass behind which is a light source, and copy the slide with the 55 mm macro Hexanon lens on the camera. However, if you have a bellows,

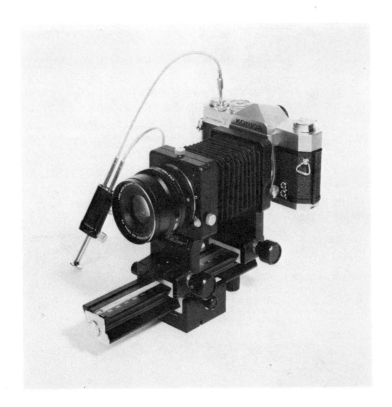

The Konica Auto Bellows with 105 mm macro Hexanon *f*/4 lens allows you to shoot extreme close-ups with precision.

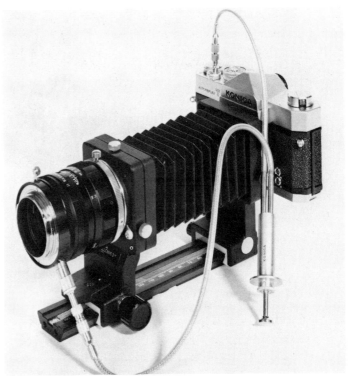

Use the Auto Ring and Double Cable Release for semi-automatic operation when the lens is in reversed position.

consider using the Konica Slide Copier, which is mounted on a calibrated, friction-drive track and can be used with a maginification chart to make enlargements of preselected size. This type of close-up work should be done with the lens reversed for optimum sharpness.

Macro Stand

This is a special copy stand used with the Auto Bellows to shoot straight down at small objects or at flat copy such as coins. The stand includes front and rear adjustment knobs for focusing, and the base is a standard 18 percent gray insert to supply an average meter reading.

Microscope Adapter 2

If you happen to work in a laboratory, or anywhere that requires taking pictures through a microscope, this adapter enables you to attach a Konica camera to the microscope. No lens is necessary, and you can view through the microscope directly and also enjoy through-the-lens metering.

In summary, how elaborately you equip yourself for close-up photography depends on the extent of your needs. In any case, Konica offers equipment and accessories for convenience and versatility.

This close-up picture of a man's eye was taken by Barbara Jacobs.

Konica Case-History Pictures

It's one thing to have top-notch equipment, and it's another to know the techniques that squeeze the most from cameras, lenses, and talent. We learn from experience, as much from mistakes as from memorable images, and we also learn from examples, a few of which follow. First, here is a brief review of ingredients that help make an outstanding photograph.

WHAT MAKES AN OUTSTANDING PHOTOGRAPH?

Composition

The way a picture situation is seen and designed through the viewfinder of a camera becomes the composition of an image. There are principles that govern the arrangement of forms, lines, colors, and spatial relationships within a photograph. Awareness of effective composition is a true advantage to the camera enthusiast.

Lighting

Lighting is an ally of composition because it shows from or hides it. Lighting evokes mood, accents expression, and underlines action. There are many forms of daylight—sun, clouds, rain, fog, and haze are among them—but you should be familiar with floodlighting and flash as well. *Look at the light* as you take pictures, and if changing your camera position or moving a subject might improve the shot, do it. Changes in lighting effects are often subtle, but there's a payoff when your prints or slides have that special distinction due to skillfully managed light.

Timing

"Luck is when opportunity meets preparation." That definition describes some moments when you depress the shutter-release button of your Konica and capture exciting peak action of special emotion on someone's face. Good timing takes practice, as well as the study of your slides and prints to know their pros and cons. A well-developed sense of timing helps separate the amateurs from the pros.

Craftsmanship

This category is a combination of all the remaining ingredients of fine photography, including the proper choice of film or lens, and the time and place you choose to shoot. Craftsmanship also means cleanliness in handling film and equipment, in working in the darkroom, and later in filing or preserving your images. You must take pride in being precise and in working carefully, even if you need to work quickly. Editing your proofs and slides ruthlessly provides more interesting displays and makes you look better—because you are bet-

ter. Craftsmanship means caring enough to take the pains that quality photography demands.

Read other books (the publisher of this one lists hundreds more) and look regularly at photographic magazines in which contemporary work is shown. Increased awareness of the possibilities your camera offers leads to greater involvement—and satisfaction. Just don't be the cartoon character who shows off his valuable equipment, but rarely uses it.

CASE HISTORY PICTURES

The following pictures are only a sampling of the photographic opportunities Konica owners are likely to meet. The selection is typical, but of course not complete, because thre are so many ways to see and show the world around us with the fine cameras and lenses which are available today.

For a concluding note, let every example in this chapter and book stimulate you to try new things and perfect older techniques. A Konica Autoreflex is a worthy machine in the hands of those who reach to meet challenges of the photographic medium.

Good shooting!

The model in this photograph was asked to float near the deep end of the pool, close enough to the underwater light to show some detail of her figure. The sharp separation of light and shadow areas was intriguing, due to the spotlight-like effect of the pool light. Using a 28 mm Hexanon lens to get a wide enough view from the edge of the pool, this shot was made at 1/60 sec. on Kodak Tri-X film normally rated at ASA 400. The same image could have been taken on Kodak Ektachrome 200 or Kodacolor 400 film without special processing, although a daylight-type color film would have produced rather warm tones from the tungsten illumination.

Never underestimate the close-up capability of your normal 50 mm Hexanon lens (all apertures and models included), which will focus on a subject just 18 inches from the film plane. These leaves were photographed just after a rain when the sky was overcast and the light was soft. There's a little more area on the negative, which was cropped to this format to make the two leaves dominant. The lens used was the 50 mm f/1.4 Hexanon, with a lens hood, and the film used was Kodak Plus-X. The camera was hand-held for a 1/125 sec. f/8 exposure.

Portraits made by diffused daylight outdoors or near a suitable window can offer the advantages of soft studio lighting, while making the subject comfortable. Actress Celeste Yarnall was photographed with a 100 mm f/2.8 Hexanon lens on Kodak Tri-X film rated at ASA 200 to compensate for the bright, white background wall. The portrait was printed with a slight diffusion through several layers of nylon stocking material held under the lens for half the exposure.

One exciting aspect of photography is picturing something in a way the average viewer doesn't see it, a talent we associate with names such as Edward Weston, Wynn Bullock, Henri Cartier-Bresson, or W. Eugene Smith. It is a challenge to extract an unusual image from a fairly obvious subject; an attempt was made to do this with the steel sculpture by Alexander Liberman at the Los Angeles County Museum of Art. These fascinating forms have been approached a number of times with lenses ranging from 15 mm to 135 mm, experimenting with perspective and the relationships of a work that is at least 12 feet high. This version was one of a series made with a normal 50 mm f/1.7 lens in late afternoon, when the shadows are most interesting. Is there a structure (it need not be sculpture) near you worth visual exploration over a period of time?

113

A leaping motorcyclist was caught in midair by G. Murray Gauer of British Columbia, using a 52 mm f/1.8 Hexanon lens and a 2X teleconverter on his Konica N-T3. Gauer shot on Ilford FP4 film (ASA 125) at 1/1000 sec. at f/8 panned the camera with the rider. In other words, he followed the action through the Konica viewfinder and shot at the peak, thereby assuring a sharp main subject and a slightly blurry background. Try panning at shutter speeds of 1/125 sec. and faster when direct shooting does not guarantee sharpness.

The larger aperture of an *f*/1.4 lens was advantageous at deep dusk in Salzburg, Austria, where this shot was taken. A tree was used to brace against, and the aperture was wide open at 1 sec., which is what the meter indicated for the medium-fast, Plus-X film in the camera. A faster film would have permitted a slower lens, but the contrast characteristics of Plus-X film proved to be favorable in this photo. In the enlargement, there's a bit of camera movement showing, but one may rationalize that it adds to the atmosphere.

It's the sky of the 4th of July, when fireworks in motion trace squiggly lines or become bursts of light on film. Using Kodak Plus-X film, and bracketing, 1 sec. at f/8 or f/11 was enough exposure to create patterns, but not overexposure. Bracketing means to shoot one stop or one-half stop more and less than the meter-indicated exposure. In this case, because the intensity of the light varies quickly, you guess exposure according to the speed of the film and bracket alternately on both sides of your educated guess. In color, overlapping hues add to the pictorial impact of fireworks, which you may shoot with a 50 mm normal lens, though 100 mm or longer is usually preferable.

To discover agreeable things accidentally is *serendipity,* and that's one way to describe zoom-during-exposure pictures. Lighting conditions must be such that you can shoot at 1/2 sec. or longer, although 1 sec. is preferable for a variety of effects. Place your Konica on a tripod and zoom the lens in either direction while the shutter is open. This view of downtown Los Angeles was exposed for 12 seconds on Kodak Plus-X film with the 80–200 mm UC Hexanon zoom lens set at *f*/8. Shots were also made at *f*/11 and *f*/16 to bracket the time. In color, zoom-during-exposure pictures have an added attraction, but are still unpredictable.

While the setting of a UCLA classroom of Far Eastern musical instruments is unusual, use of a 28 mm f/2.8 Hexanon lens for wide-angle coverage is fairly conventional, as is the contact proof of negatives from which the photographer can edit. Of the 12 exposures made in a space of perhaps 5 minutes (all at 1/60 sec. at f/5.6 or f/6.3), only one is vertical. Why was frame number 27 chosen to be enlarged? It seemed to have an orderliness of form and pattern that helped explain the situation quickly and without certain confusing elements found in other frames. Cropping frame 27 into a stronger horizontal also gives it more impact. Study your own contact proofs with a magnifying glass to determine which frame or frames most deserve to be blown up for your purposes.

INDEX